Andy Warhol

A GRAPHIC BIOGRAPHY

Quarto

First published in 2024 by Frances Lincoln,
an imprint of The Quarto Group.
One Triptych Place, London, SE1 9SH,
United Kingdom
T (0)20 7700 9000
www.Quarto.com

A catalogue record for this book is available from the British Library.

ISBN 978-0-7112-9078-5
Ebook ISBN 978-0-7112-9319-9

10 9 8 7 6 5 4 3 2 1

Publisher: Philip Cooper
Commissioning Editor: John Parton
Senior Editor: Laura Bulbeck
Senior Designer: Renata Latipova
Production Controller: Rohana Yusof

Printed in China

Andy Warhol

A GRAPHIC BIOGRAPHY

TEXT BY
MICHELE BOTTON

ILLUSTRATIONS BY
MARCO MARAGGI

TRANSLATION BY
EDWARD FORTES

EDITED BY
BALTHAZAR PAGANI

FRANCES
LINCOLN

Contents

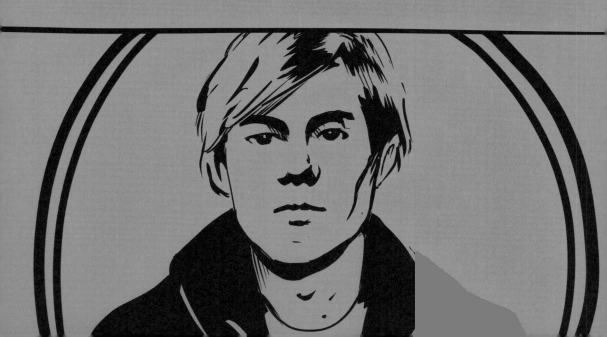

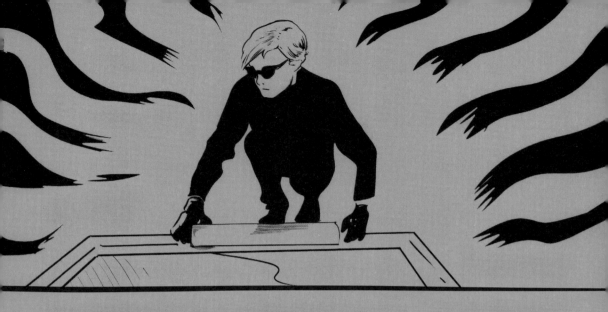

Andy Warhol

YOU KNOW WHO I MEAN?

YOU'VE SEEN HIS WORK EVERYWHERE. — YOU'VE SEEN HIS FACE ON TV, IN NEWSPAPERS, AND ON BILLBOARDS ADVERTISING HIS EXHIBITIONS. YES: THAT IS ANDY WARHOL AND HE IS THE SOUL OF POP ART.

But first things first: POP ART IS SHORT FOR 'POPULAR ART', an artistic movement that was born in Britain in the mid-1950s and came of age in the United States in the early 1960s. The artists of the movement were often INSPIRED BY OBJECTS DRAWN FROM EVERYDAY LIFE, and in most cases their aim was to CREATE A COMMERCIAL OBJECT like the ones that overwhelmed the public imagination in those years. Warhol was the artist most able to give a shape to this movement, setting new rules and standards in terms of execution and production.

Andy Warhol was born Andrew Warhola Jr in Pittsburgh, Pennsylvania, in 1928. He moved to New York at the age of 21 and immediately began working in advertising, receiving excellent feedback on his work. His ambition, however, was Art with a capital 'A' – a field in which he soon began to roam with an eclecticism unparalleled among his contemporaries: as a painter, illustrator, graphic designer, director, record producer and filmmaker. **WARHOL WAS A UNIQUE CHARACTER.**

THANKS TO HIS ABILITY TO PREDICT AND READ THE MARKET, HE MANAGED TO RIDE THE WAVE OF SUCCESS FOR NEARLY 40 YEARS.

Warhol transformed his style and expanded his areas of activity based on how society was changing and how the art system evolved. He was an absolute master at making people **TALK ABOUT HIM**: his clothes ranged from the elegant to the extravagant; he wore eye-catching wigs that became iconic; and yet he proved shy and elusive in interviews. He always took part in worldly events with this restrained, almost absent air – and yet he surrounded himself with big personalities. He set up **THE FACTORY**, to which artists of all kinds were drawn and where unparalleled creative chaos reigned – but in private he kept to himself. And he combined visually impactful artworks with this larger-than-life profile. At least two souls lived side by side in this complex, **MULTIFACETED CHARACTER**.

One is the artist ahead of his time, constantly at the centre of things: the brilliant king of marketing with the advertising executive temperament, who held the New York – and global – art scene in the palm of his hand.

THE OTHER WAS THE PRIVATE 'ANDY', RELUCTANT TO REVEAL HIS FRAGILE AND MELANCHOLIC SIDE.

WHERE DOES THE ARTIST END AND THE MAN BEGIN? To what extent did Warhol construct this personal mythology for public use and consumption? As well as the creative individual, in this graphic novel I try to tell the story of the private Andy, a man so evasive he risked giving the impression he lacked empathy. I have chosen to tell the story of WARHOL'S LIFE in a straightforward, chronological manner, narrating the events, friendships and way of making art that show how Warhol came across and who he was.

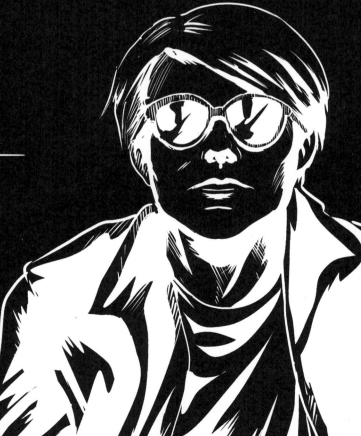

Warhol created his work and exhibitions, but he allowed the audience to interpret what they saw according to their own tastes and sensibilities. I did the same when telling his story: I adopted a panoramic view and aimed for a historically accurate,

HONEST ACCOUNT
IN THE PORTRAYAL
OF WHAT WAS A
KALEIDOSCOPIC LIFE,
NEITHER JUDGING IT
NOR DRAWING ANY
FIRM CONCLUSIONS.

NOW IT'S UP TO YOU TO READ
THAT LIFE AND CHOOSE
WHICH ANDY WARHOL
TO DISCOVER OVER THE
FOLLOWING PAGES.

Michele Botton

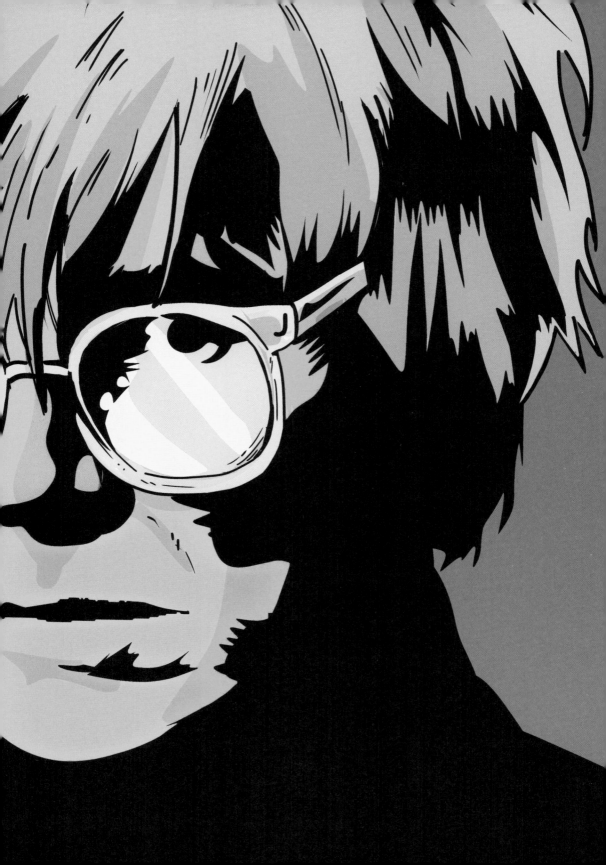

Early life in Pittsburgh

A YOUNG ANDREW WARHOLA JR
GROWS UP AND TAKES
HIS FIRST STEPS
IN THE WORLD OF WORK.

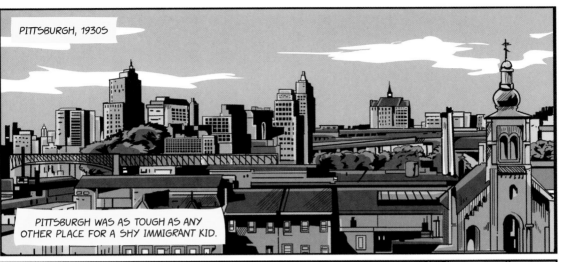

IN FACT, ANDY: WHAT DO YOU SAY TO COMING TO CHURCH WITH ME? YOU CAN CONTINUE READING AFTERWARDS.

OK, MOM.

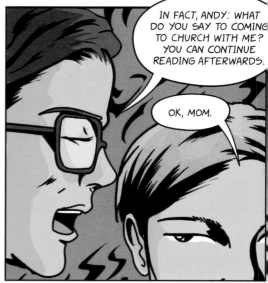

JOHN, DON'T BOTHER YOUR BROTHER: YOU KNOW HE'S NOT A LITTLE FIRECRACKER LIKE YOU. LET HIM ALONE.

MOM WAS ALWAYS KIND TO ME.

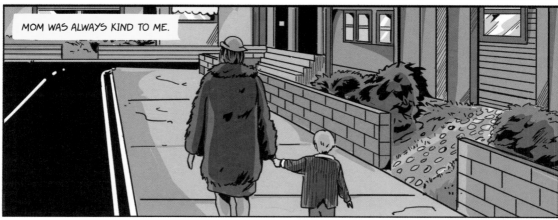

SOMETIMES DAD WAS THERE; SOMETIMES HE WASN'T. SOMETIMES HE HAD WORK; SOMETIMES HE DIDN'T. AND THEN HE DIED.

MY BROTHERS... WERE JUST BROTHERS.

I FELT BETTER AT HOME.

I WOULD READ MY COMICS.

AND DRAW.

I LOVED DRAWING.

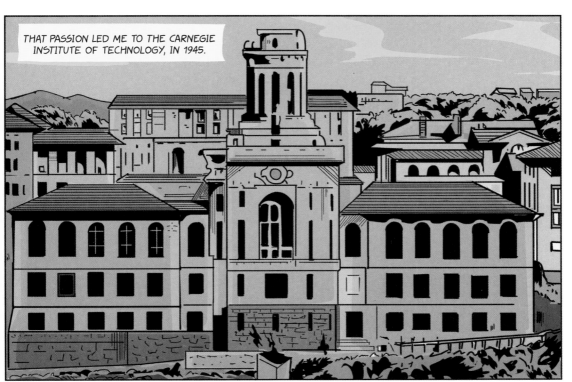

THAT PASSION LED ME TO THE CARNEGIE INSTITUTE OF TECHNOLOGY, IN 1945.

I STUDIED ART, DESIGN AND COMMERCIAL ART.

IT WAS A STIMULATING ENVIRONMENT.

BUT SOCIALLY COMPLICATED. AND YET SOMEHOW...

HEY, ANDREW!

HI, PHILIP.

PHILIP PEARLSTEIN, A PAINTER AND FRIEND.

SHALL WE GET LUNCH?

TO BE HONEST, I'M NOT THAT HUNGRY...

SO WHAT? I AM. AND ANYWAY: WE'VE GOTTA TALK, SO IT'S ALWAYS GOOD TO HAVE SOMETHING BETWEEN YOUR TEETH! COME ON!

... OK ...

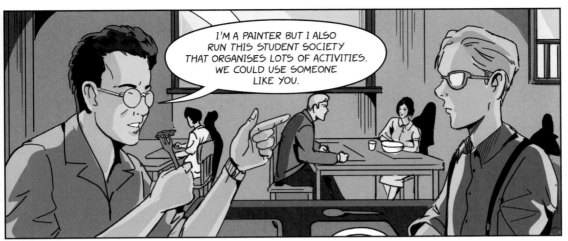

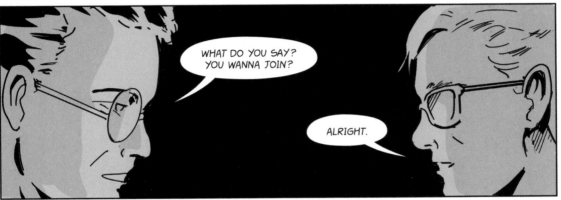

PHILIP BECAME A GOOD FRIEND.

FOR A WHILE, WE WANTED THE SAME THINGS.

IT WAS A GOOD TIME. I WORKED AS THE PICTURE EDITOR OF A UNIVERSITY MAGAZINE.

ONE SUMMER I DID THE WINDOW DRESSING AT JOSEPH HORNE'S, A BIG DEPARTMENT STORE IN DOWNTOWN PITTSBURGH.

HEY, ANDY, HOW'S IT GOING?

DON'T YOU THINK SHIRLEY TEMPLE IS JUST ADORABLE?

UMM... YEAH, I GUESS SO.

BY 1949, PITTSBURGH WAS TOO SMALL FOR US.

PHILIP, NOW THAT WE'VE GRADUATED...

WE SHOULD MOVE TO A CITY THAT HAS MORE OPPORTUNITIES FOR US?

EXACTLY.

YOU'VE GOT AMBITION, ANDY. I NEVER SAW YOU AS THAT DETERMINED.

I JUST WANT TO BE SUCCESSFUL.

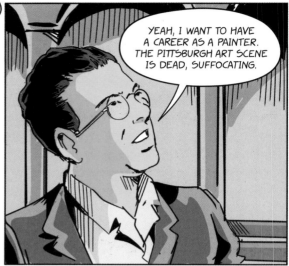

YEAH, I WANT TO HAVE A CAREER AS A PAINTER. THE PITTSBURGH ART SCENE IS DEAD, SUFFOCATING.

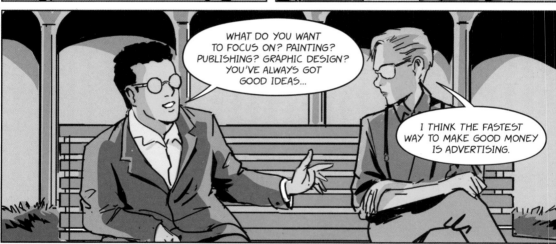

WHAT DO YOU WANT TO FOCUS ON? PAINTING? PUBLISHING? GRAPHIC DESIGN? YOU'VE ALWAYS GOT GOOD IDEAS...

I THINK THE FASTEST WAY TO MAKE GOOD MONEY IS ADVERTISING.

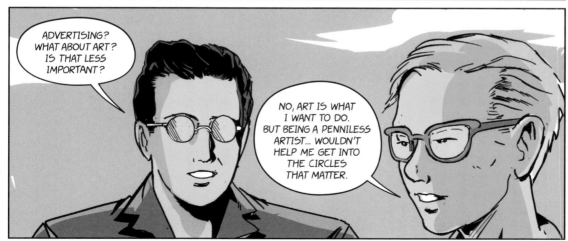

ADVERTISING? WHAT ABOUT ART? IS THAT LESS IMPORTANT?

NO, ART IS WHAT I WANT TO DO. BUT BEING A PENNILESS ARTIST... WOULDN'T HELP ME GET INTO THE CIRCLES THAT MATTER.

New York

A NEW CITY, A NEW LIFE.
WARHOL MAKES A CAREER
IN ADVERTISING – BUT BEING
AN ARTIST IS AN UPHILL STRUGGLE.

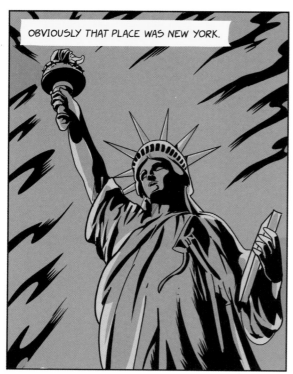

OBVIOUSLY THAT PLACE WAS NEW YORK.

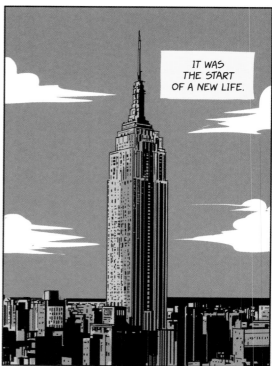

IT WAS THE START OF A NEW LIFE.

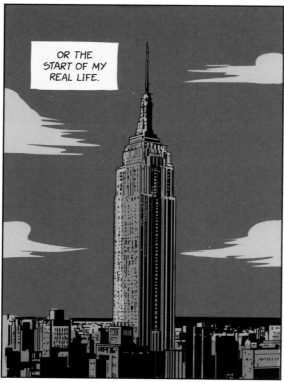

OR THE START OF MY REAL LIFE.

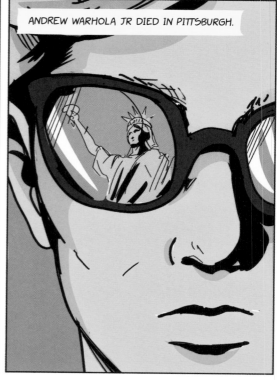

ANDREW WARHOLA JR DIED IN PITTSBURGH.

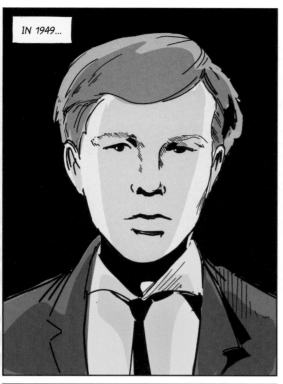

IN 1949...

... IN NEW YORK...

... I CHANGED MY NAME.

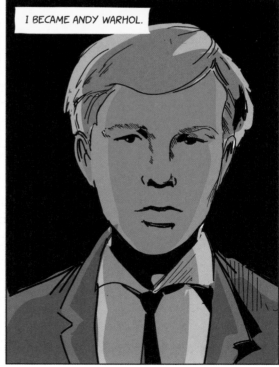

I BECAME ANDY WARHOL.

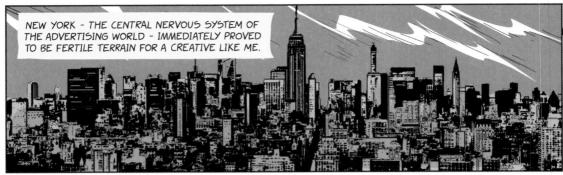

NEW YORK – THE CENTRAL NERVOUS SYSTEM OF THE ADVERTISING WORLD – IMMEDIATELY PROVED TO BE FERTILE TERRAIN FOR A CREATIVE LIKE ME.

YEAH, I LIKE THESE.

WHAT ELSE YOU WORKING ON, ANDY?

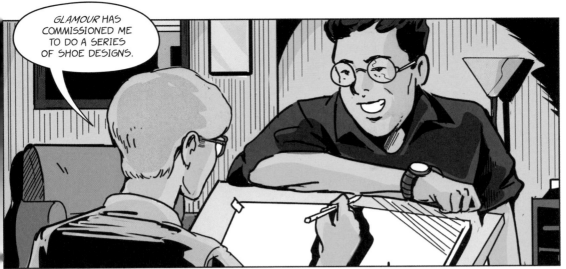

GLAMOUR HAS COMMISSIONED ME TO DO A SERIES OF SHOE DESIGNS.

VOGUE FOLLOWED GLAMOUR IN ASKING ME FOR ADVERTISING WORK. AFTER VOGUE, THERE WERE OTHERS.

BUSINESS WAS GOOD. A YEAR LATER, THE RUNDOWN APARTMENT I SHARED WITH PHILIP WASN'T FOR ME ANYMORE.

WE WENT OUR SEPARATE WAYS.

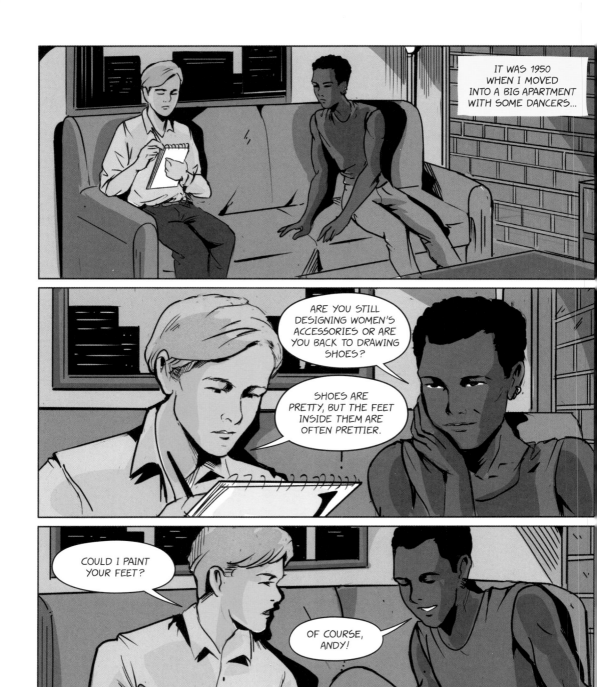

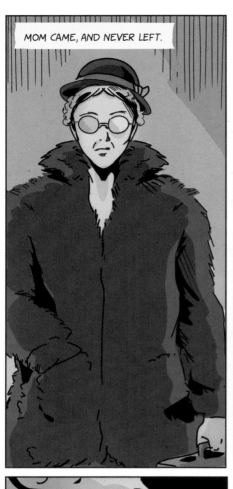

MOM CAME, AND NEVER LEFT.

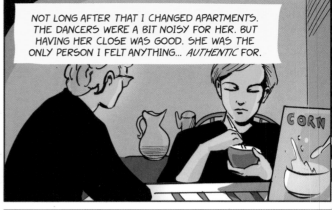

NOT LONG AFTER THAT I CHANGED APARTMENTS. THE DANCERS WERE A BIT NOISY FOR HER. BUT HAVING HER CLOSE WAS GOOD. SHE WAS THE ONLY PERSON I FELT ANYTHING... *AUTHENTIC* FOR.

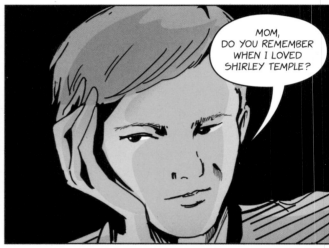

MOM, DO YOU REMEMBER WHEN I LOVED SHIRLEY TEMPLE?

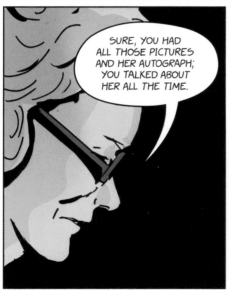

SURE, YOU HAD ALL THOSE PICTURES AND HER AUTOGRAPH; YOU TALKED ABOUT HER ALL THE TIME.

NOW I THINK I FEEL THE SAME ADMIRATION FOR TRUMAN CAPOTE. I'D REALLY LOVE TO MEET HIM.

YOU WILL, HONEY; I JUST KNOW YOU WILL.

BUSINESS WAS BOOMING. I FOUNDED ANDY WARHOL ENTERPRISES INC., WHICH QUICKLY BECAME ONE OF THE MOST SOUGHT-AFTER AD AGENCIES IN NEW YORK - AND BEYOND. MONEY WASN'T AN ISSUE ANYMORE.

BUT MONEY AND SUCCESS WEREN'T HELPING MY ART CAREER TAKE OFF.

I HAD A SMALL SOLO SHOW AT THE HUGO GALLERY IN JUNE 1952, FEATURING DRAWINGS INSPIRED BY CAPOTE'S WRITING. A FEW PEOPLE LIKED IT. THE ART WORLD IGNORED ME.

I WENT TO THE RIGHT PLACES, WHERE THE BIG NAMES OF NEW YORK'S CONTEMPORARY ART SCENE HUNG OUT.

HAVE YOU SEEN THOSE PAINTINGS?

WHICH ONES? THE ONES BY WARHOL?

JASPER JOHNS AND ROBERT RAUSCHENBERG, THE LEADING EXPONENTS OF NEO-DADA, DIDN'T PAY ME MUCH ATTENTION.

YEAH, BUT ISN'T HE AN AD GUY?

APPARENTLY HE PAINTS, TOO.

ART AND ADVERTISING ARE PRETTY DIFFERENT...

UMM... HELLO, MR CASTELLI, COULD I SPEAK WITH YOU FOR A MOMENT?

LEO CASTELLI, THE MOST INFLUENTIAL ART DEALER AND COLLECTOR OF THE TIME.

HAVING A SHOW AT THE LEO CASTELLI GALLERY AT NUMBER 420 WEST BROADWAY WAS THE ABSOLUTE HEIGHT OF SUCCESS FOR AN ARTIST.

I'M SORRY, I CAN'T RIGHT NOW. MAYBE SOME OTHER TIME.

AN AMBITION I'D HAVE TO WAIT A LITTLE LONGER TO FULFIL.

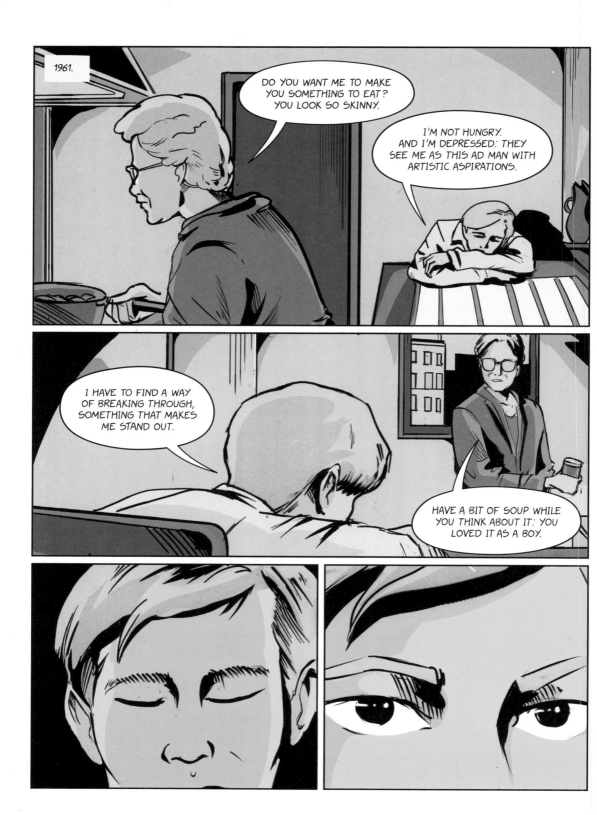

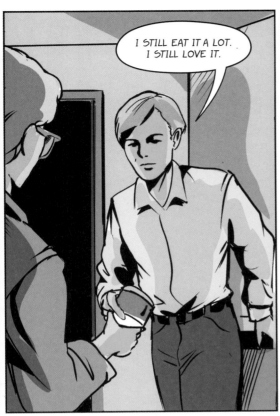

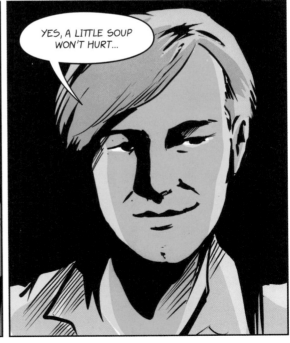

CHAPTER 2

Andy Warhol

THE PATH IS CLEAR:
AMID PORTRAITS
AND CANS OF SOUP,
THE KING OF POP ART IS BORN.

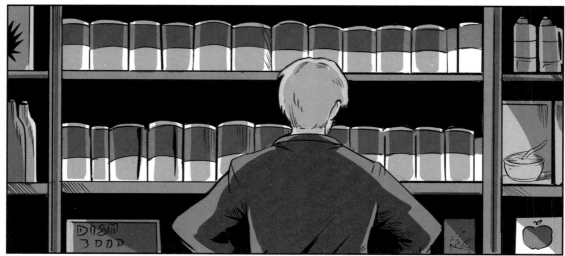

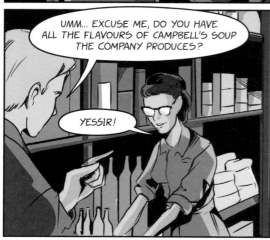

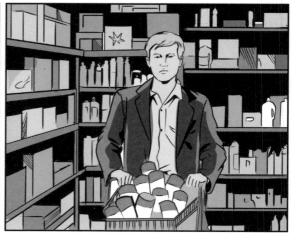

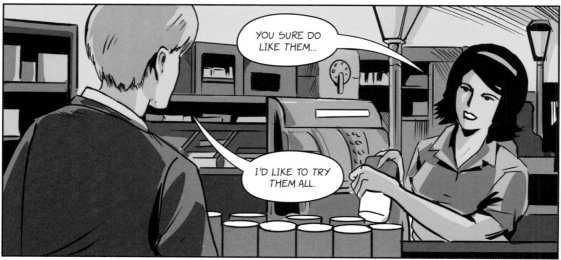

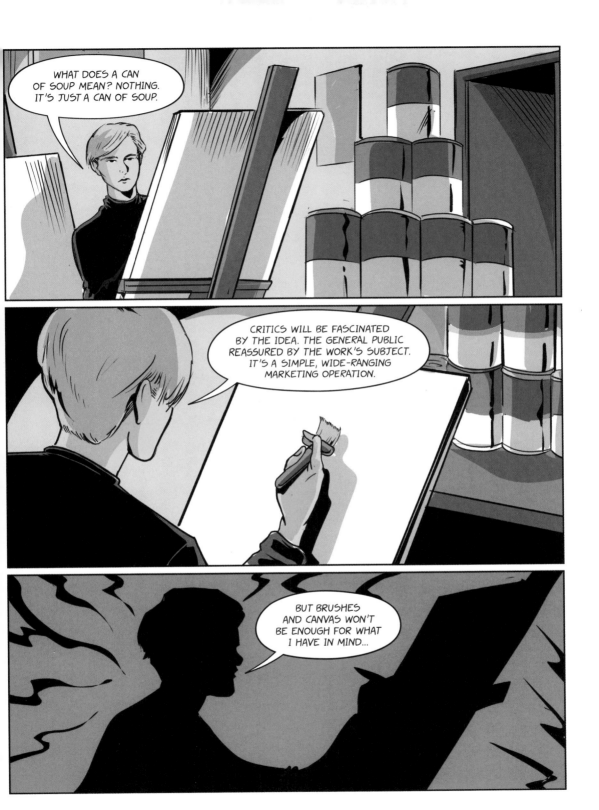

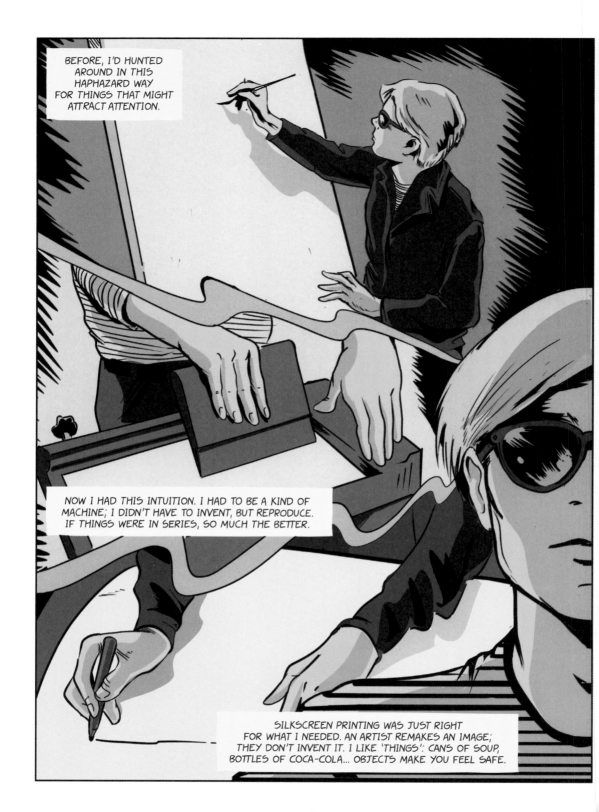

BEFORE, I'D HUNTED AROUND IN THIS HAPHAZARD WAY FOR THINGS THAT MIGHT ATTRACT ATTENTION.

NOW I HAD THIS INTUITION. I HAD TO BE A KIND OF MACHINE; I DIDN'T HAVE TO INVENT, BUT REPRODUCE. IF THINGS WERE IN SERIES, SO MUCH THE BETTER.

SILKSCREEN PRINTING WAS JUST RIGHT FOR WHAT I NEEDED. AN ARTIST REMAKES AN IMAGE; THEY DON'T INVENT IT. I LIKE 'THINGS': CANS OF SOUP, BOTTLES OF COCA-COLA... OBJECTS MAKE YOU FEEL SAFE.

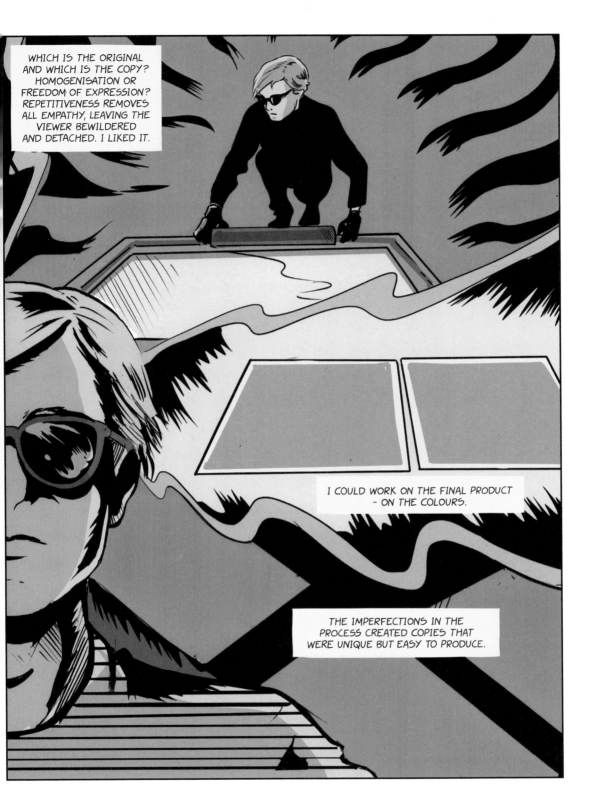

WHICH IS THE ORIGINAL AND WHICH IS THE COPY? HOMOGENISATION OR FREEDOM OF EXPRESSION? REPETITIVENESS REMOVES ALL EMPATHY, LEAVING THE VIEWER BEWILDERED AND DETACHED. I LIKED IT.

I COULD WORK ON THE FINAL PRODUCT – ON THE COLOURS.

THE IMPERFECTIONS IN THE PROCESS CREATED COPIES THAT WERE UNIQUE BUT EASY TO PRODUCE.

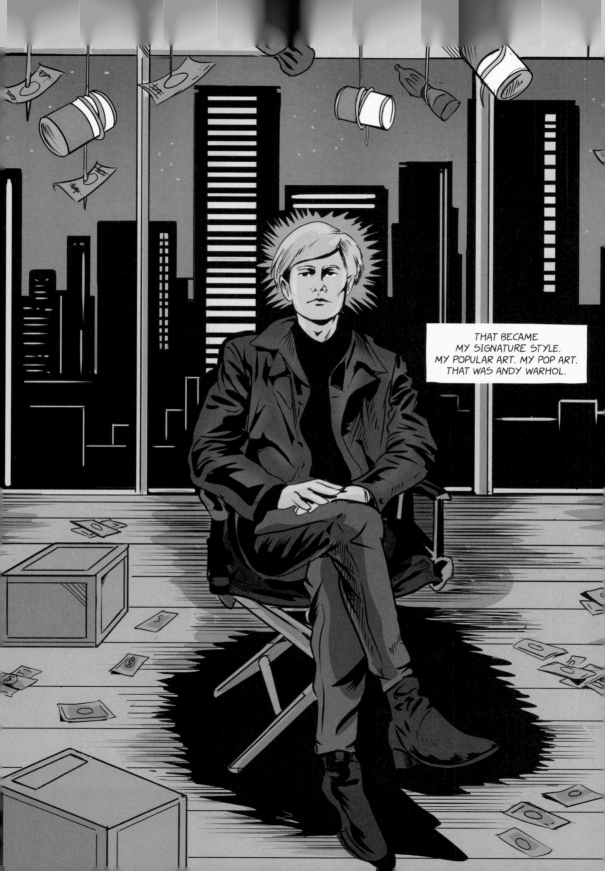

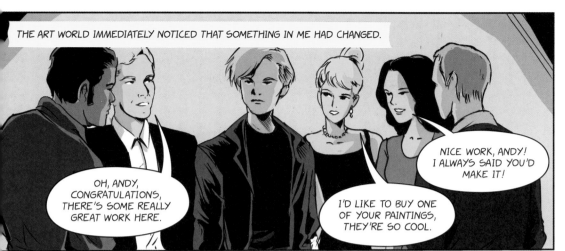

THE ART WORLD IMMEDIATELY NOTICED THAT SOMETHING IN ME HAD CHANGED.

OH, ANDY, CONGRATULATIONS, THERE'S SOME REALLY GREAT WORK HERE.

I'D LIKE TO BUY ONE OF YOUR PAINTINGS, THEY'RE SO COOL.

NICE WORK, ANDY! I ALWAYS SAID YOU'D MAKE IT!

BUT I COULDN'T STOP THERE.

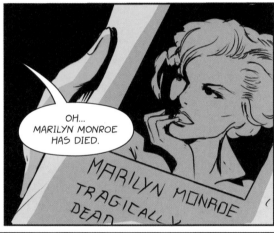

OH... MARILYN MONROE HAS DIED.

MARILYN MONROE TRAGICALLY DEAD

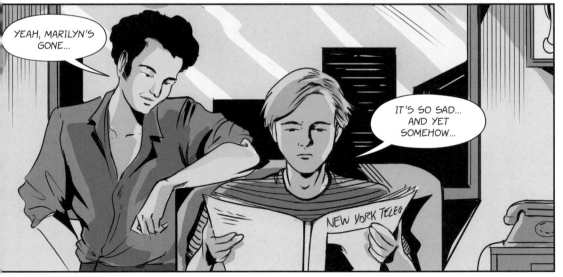

YEAH, MARILYN'S GONE...

IT'S SO SAD... AND YET SOMEHOW...

NEW YORK TELEG

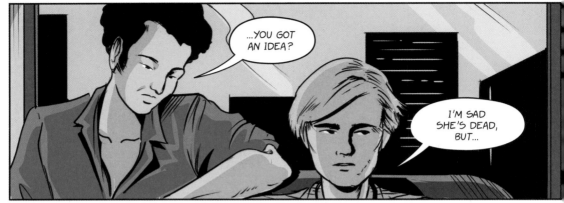

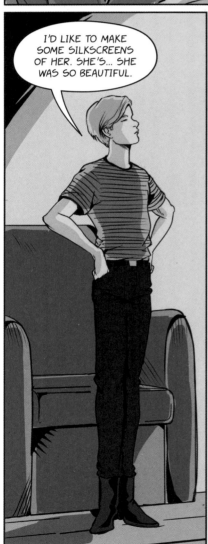

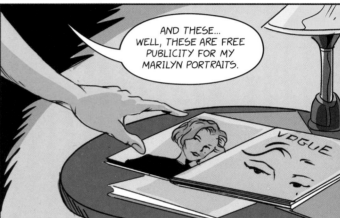

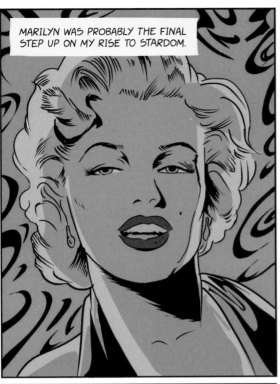

MARILYN WAS PROBABLY THE FINAL STEP UP ON MY RISE TO STARDOM.

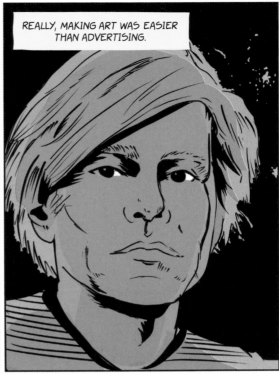

REALLY, MAKING ART WAS EASIER THAN ADVERTISING.

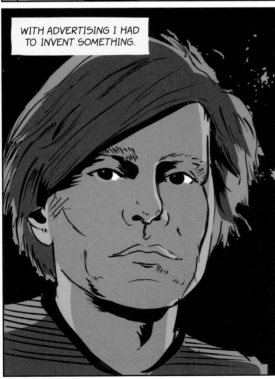

WITH ADVERTISING I HAD TO INVENT SOMETHING.

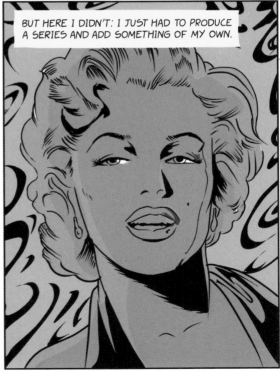

BUT HERE I DIDN'T: I JUST HAD TO PRODUCE A SERIES AND ADD SOMETHING OF MY OWN.

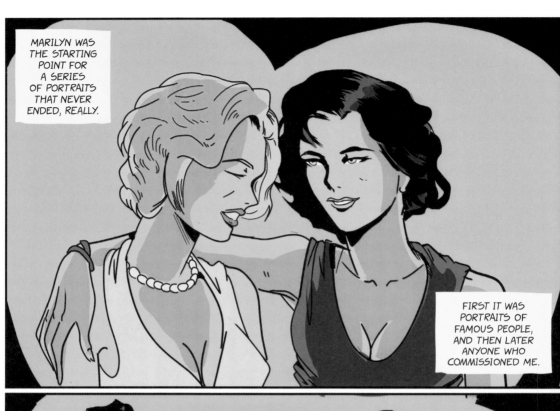

MARILYN WAS THE STARTING POINT FOR A SERIES OF PORTRAITS THAT NEVER ENDED, REALLY.

FIRST IT WAS PORTRAITS OF FAMOUS PEOPLE, AND THEN LATER ANYONE WHO COMMISSIONED ME.

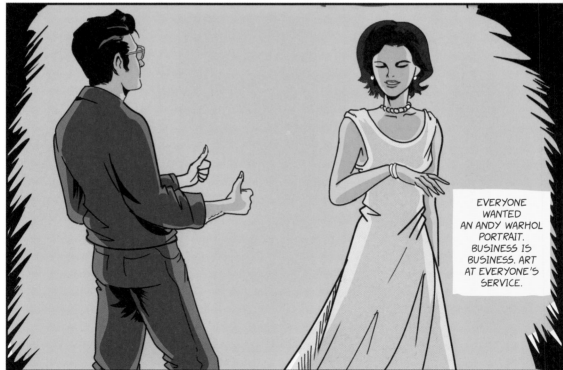

EVERYONE WANTED AN ANDY WARHOL PORTRAIT. BUSINESS IS BUSINESS. ART AT EVERYONE'S SERVICE.

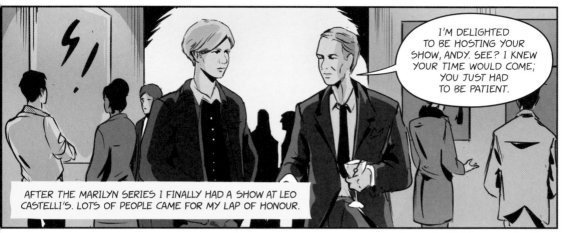

I'M DELIGHTED TO BE HOSTING YOUR SHOW, ANDY. SEE? I KNEW YOUR TIME WOULD COME; YOU JUST HAD TO BE PATIENT.

AFTER THE MARILYN SERIES I FINALLY HAD A SHOW AT LEO CASTELLI'S. LOTS OF PEOPLE CAME FOR MY LAP OF HONOUR.

ANDY, YOU'VE WON US OVER WITH THESE PIECES.

YEAH, CONGRATULATIONS.

UMM... THANK YOU.

GOOD JOB I GOT YOU TO PAINT MY PORTRAIT, HUH?

OH... WELL, IT WAS MY PLEASURE.

IN 1962 I NEEDED A LARGE SPACE TO WORK IN, AND PEOPLE AROUND ME – TALENTED PEOPLE – WHO WOULD HELP AND INSPIRE ME.

I SET UP THE FACTORY ON THE FIFTH FLOOR OF 231 EAST 47TH STREET, IN MIDTOWN MANHATTAN.

THERE'S ENOUGH SPACE, BUT IT'S MISSING SOMETHING. MAYBE I COULD DO SOMETHING TO MAKE THE PLACE A BIT MORE SPECIAL?

WHAT HAVE YOU GOT IN MIND, BILLY?

EXIT

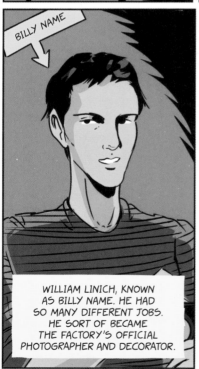

BILLY NAME

WILLIAM LINICH, KNOWN AS BILLY NAME. HE HAD SO MANY DIFFERENT JOBS. HE SORT OF BECAME THE FACTORY'S OFFICIAL PHOTOGRAPHER AND DECORATOR.

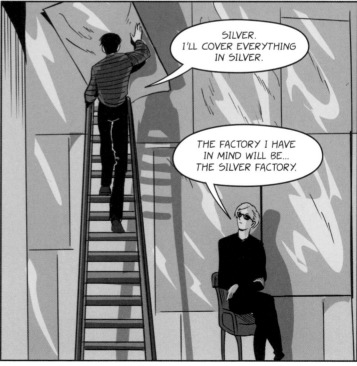

SILVER. I'LL COVER EVERYTHING IN SILVER.

THE FACTORY I HAVE IN MIND WILL BE... THE SILVER FACTORY.

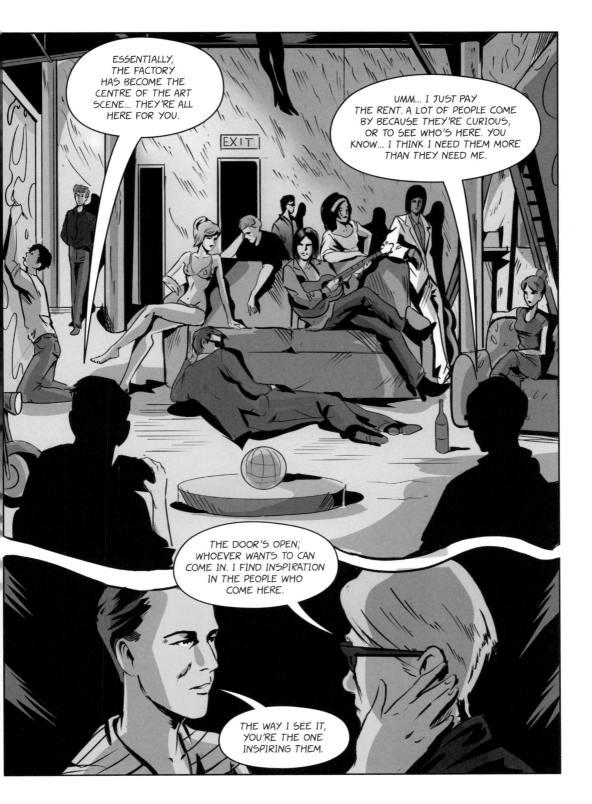

55

Music and cinema

ECLECTICISM AS STYLE: AN ARTIST
CAN'T SURVIVE ON PAINTINGS ALONE.
WARHOL WORKS IN LOTS
OF DIFFERENT FIELDS.

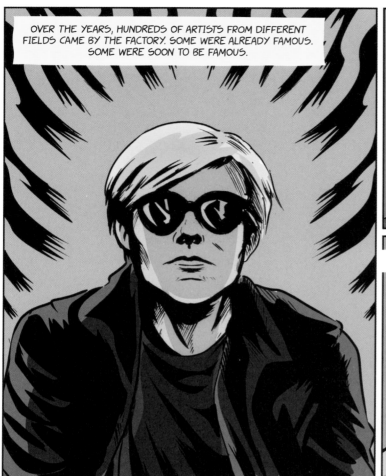

OVER THE YEARS, HUNDREDS OF ARTISTS FROM DIFFERENT FIELDS CAME BY THE FACTORY. SOME WERE ALREADY FAMOUS. SOME WERE SOON TO BE FAMOUS.

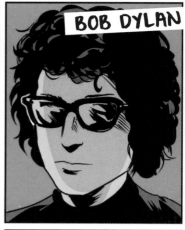

BOB DYLAN

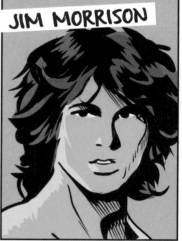

JIM MORRISON

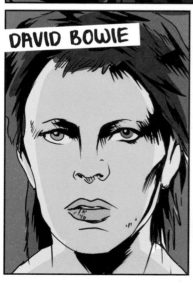

DAVID BOWIE

TRUMAN CAPOTE

VIVA
JANET SUSAN MARY HOFFMANN

MICK JAGGER

KEITH RICHARDS

BRIAN JONES

KEITH HARING

DEBBIE HARRY

ONDINE
ROBERT OLIVO

ULTRA VIOLET
ISABELLE COLLIN
DUFRESNE

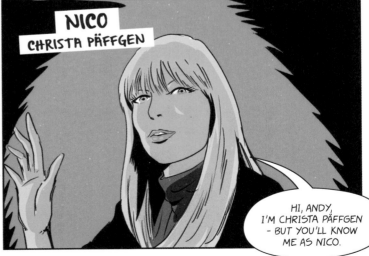

NICO
CHRISTA PÄFFGEN

HI, ANDY, I'M CHRISTA PÄFFGEN - BUT YOU'LL KNOW ME AS NICO.

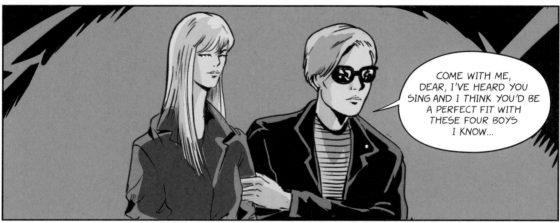

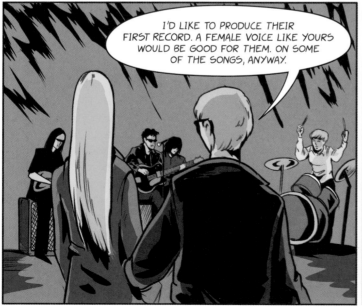

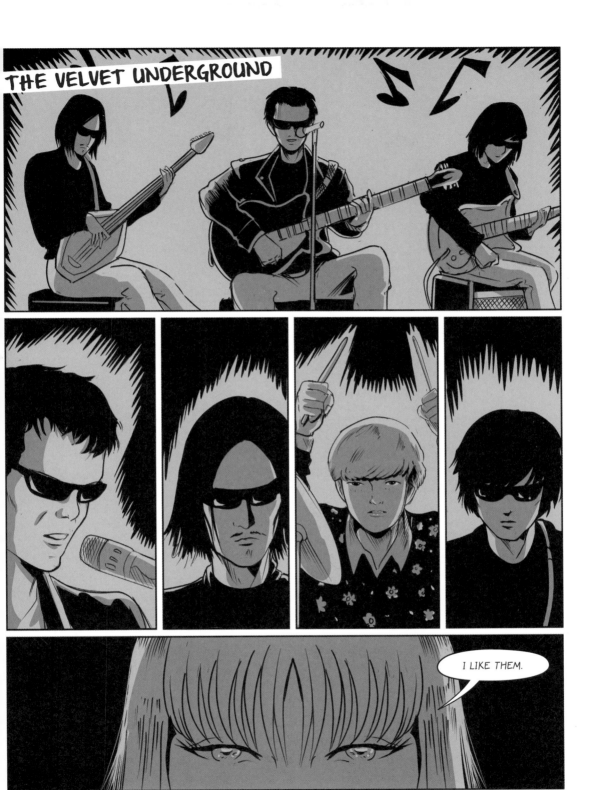

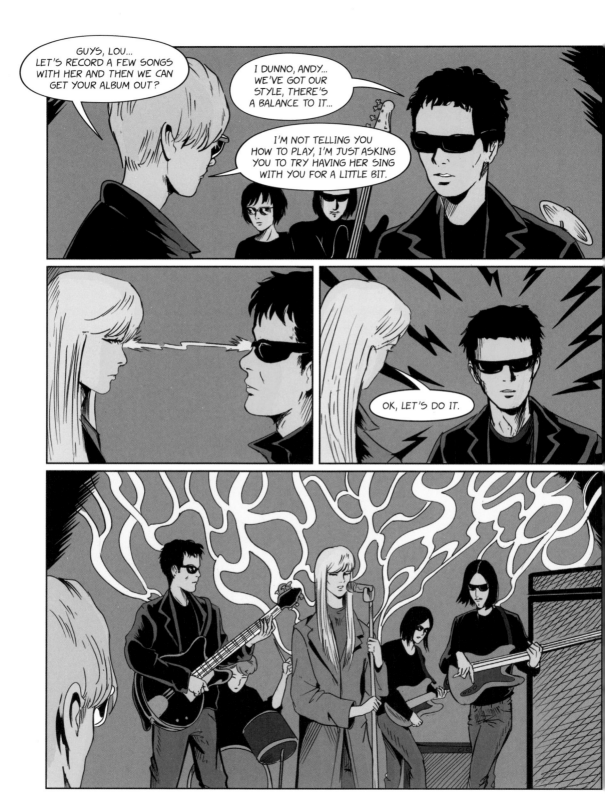

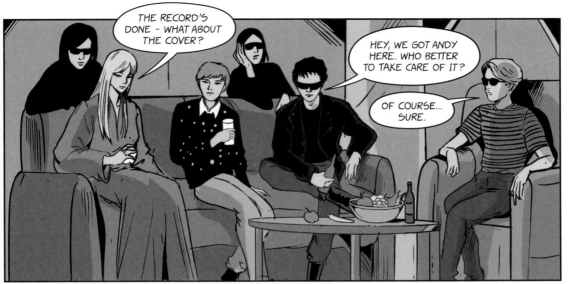

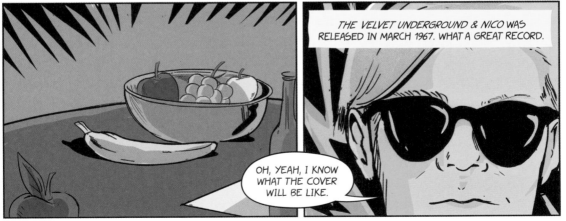

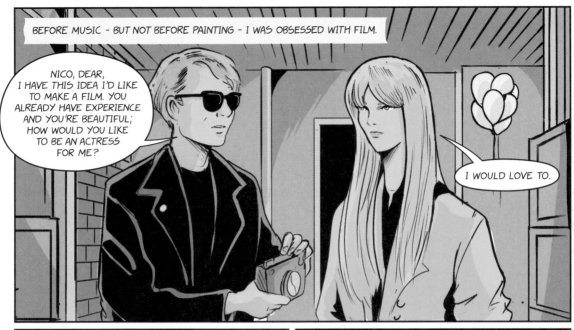

BEFORE MUSIC – BUT NOT BEFORE PAINTING – I WAS OBSESSED WITH FILM.

NICO, DEAR, I HAVE THIS IDEA I'D LIKE TO MAKE A FILM. YOU ALREADY HAVE EXPERIENCE AND YOU'RE BEAUTIFUL; HOW WOULD YOU LIKE TO BE AN ACTRESS FOR ME?

I WOULD LOVE TO.

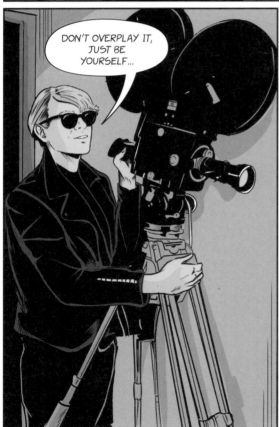

DON'T OVERPLAY IT, JUST BE YOURSELF...

THAT'S ASKING A LOT...

JOHN GIORNO WAS A POET AND A GOOD FRIEND; HE SUPPORTED ME BECAUSE HE WANTED TO, NOT BECAUSE HE COULD GET SOMETHING OUT OF IT.

SO NOW YOU'RE A FILM DIRECTOR?

AREN'T WE ALL TRYING TO BE THE DIRECTORS OF WHAT SURROUNDS US?

WITHOUT EVER REALLY SUCCEEDING.

AND WHAT KIND OF FILMS DO YOU WANT TO MAKE?

I DON'T KNOW, I'D LIKE TO EXPERIMENT, CREATE. OR MAYBE JUST SHOW BORING REAL LIFE THE WAY IT IS?

AND WHAT PART DO I HAVE TO PLAY IN THE FILM YOU HAVE IN MIND FOR ME?

OH, YOU'LL HAVE TO SLEEP.

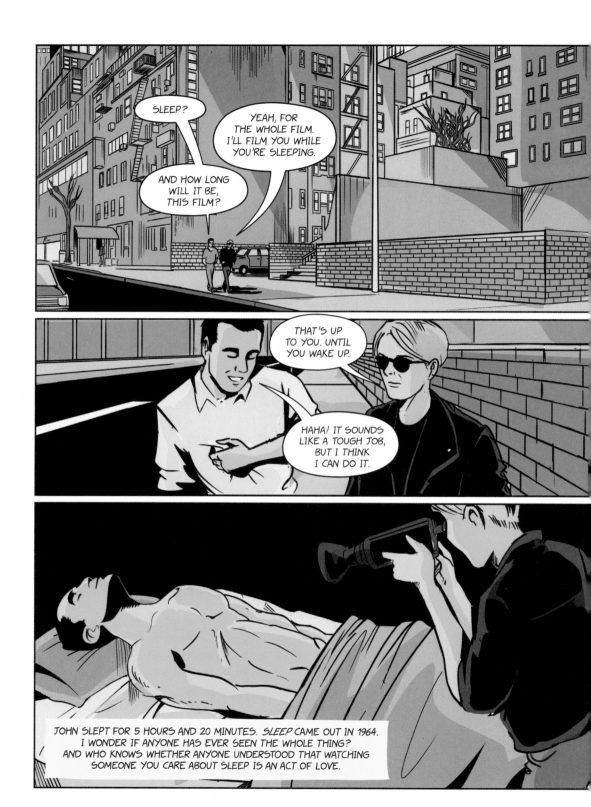

MY FILMS NEEDED AN ICON. A MUSE.

WHAT A BEAUTIFUL GIRL...

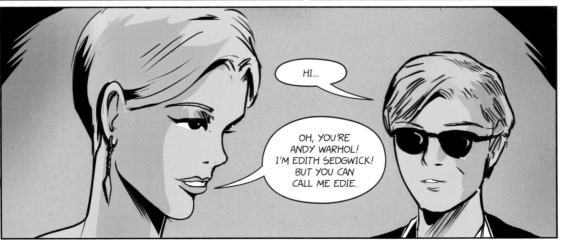

HI...

OH, YOU'RE ANDY WARHOL! I'M EDITH SEDGWICK! BUT YOU CAN CALL ME EDIE.

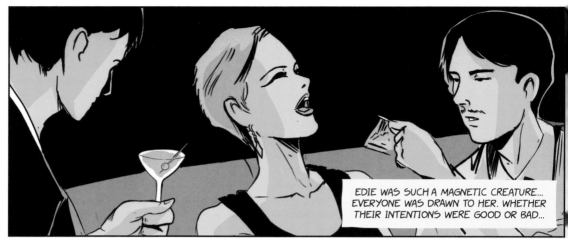

EDIE WAS SUCH A MAGNETIC CREATURE... EVERYONE WAS DRAWN TO HER. WHETHER THEIR INTENTIONS WERE GOOD OR BAD...

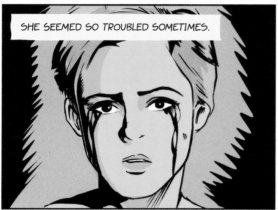

SHE SEEMED SO TROUBLED SOMETIMES.

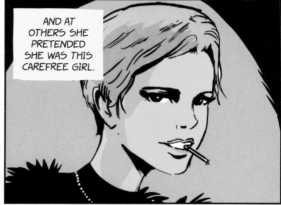

AND AT OTHERS SHE PRETENDED SHE WAS THIS CAREFREE GIRL.

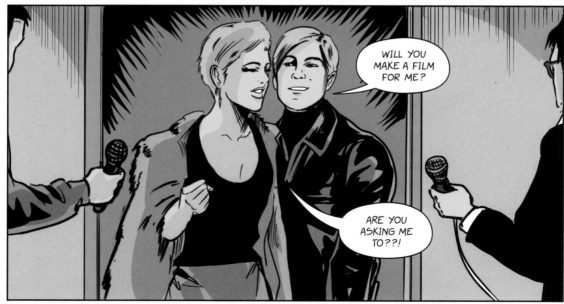

WILL YOU MAKE A FILM FOR ME?

ARE YOU ASKING ME TO??!

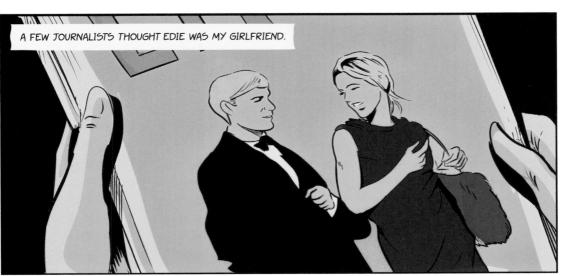

A FEW JOURNALISTS THOUGHT EDIE WAS MY GIRLFRIEND.

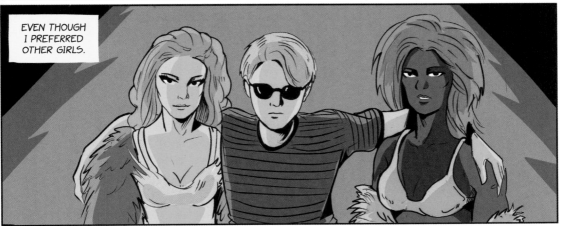

EVEN THOUGH I PREFERRED OTHER GIRLS.

OTHER KINDS OF LOVE.

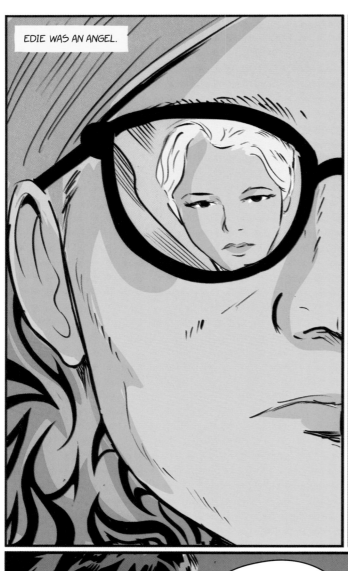

EDIE WAS AN ANGEL.

BUT AN ANGEL ON A ROAD THAT DIDN'T LEAD TO PARADISE.

THE PRESS DINED OUT ON HER...

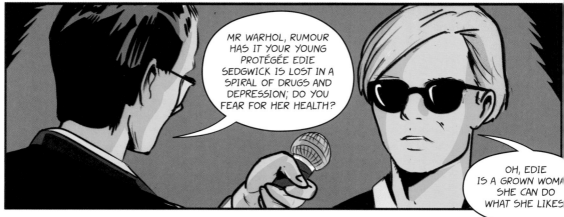

MR WARHOL, RUMOUR HAS IT YOUR YOUNG PROTÉGÉE EDIE SEDGWICK IS LOST IN A SPIRAL OF DRUGS AND DEPRESSION; DO YOU FEAR FOR HER HEALTH?

OH, EDIE IS A GROWN WOMA SHE CAN DO WHAT SHE LIKES

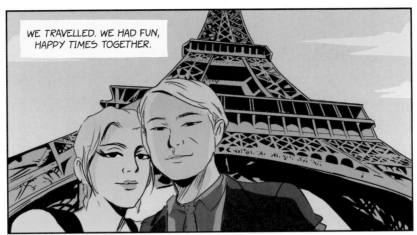

WE TRAVELLED. WE HAD FUN, HAPPY TIMES TOGETHER.

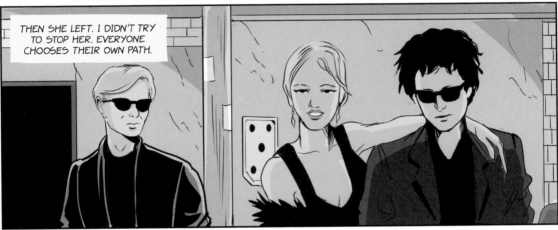

THEN SHE LEFT. I DIDN'T TRY TO STOP HER. EVERYONE CHOOSES THEIR OWN PATH.

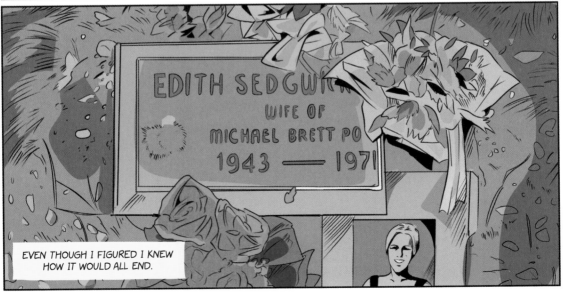

EDITH SEDGWICK
WIFE OF
MICHAEL BRETT PO
1943 — 1971

EVEN THOUGH I FIGURED I KNEW HOW IT WOULD ALL END.

CHAPTER 4

Bang!

WE ALMOST LOSE OUR HERO
BEFORE HIS TIME – AND HE COMES
OUT OF IT WITH A FEW BRUISES
TO BODY AND SOUL.

THE FACTORY WAS STILL THRIVING.

IS IT LIKE THIS EVERY DAY?

IT'S ALWAYS CHAOS AROUND HERE.

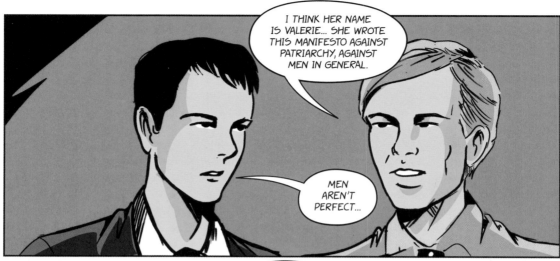

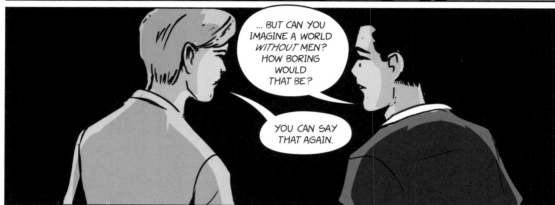

HER NAME WAS VALERIE SOLANAS.

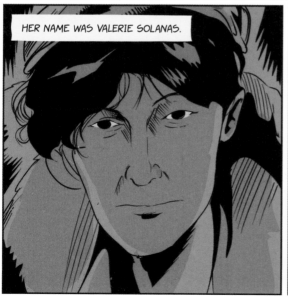

I NEVER FORGOT THAT NAME.

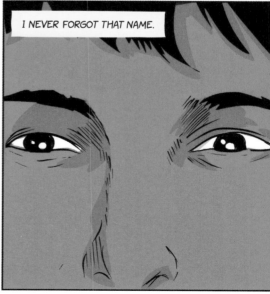

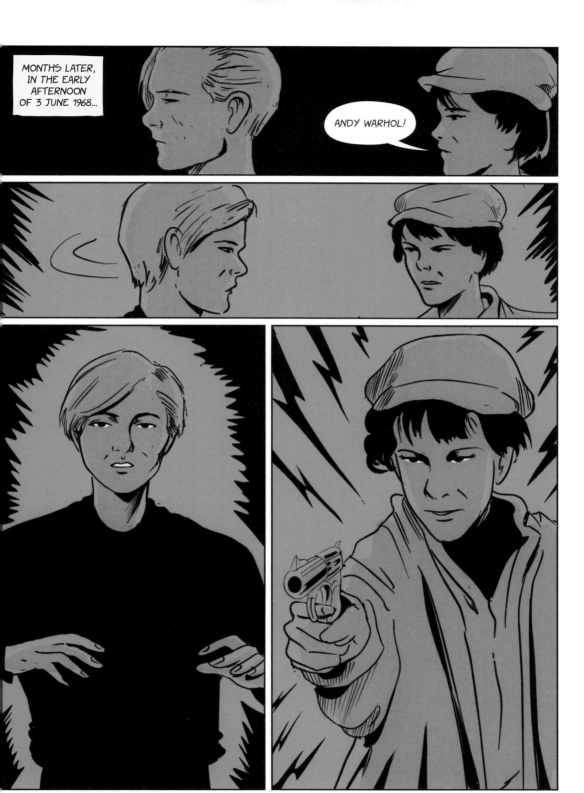

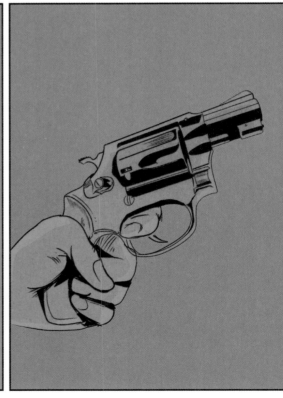

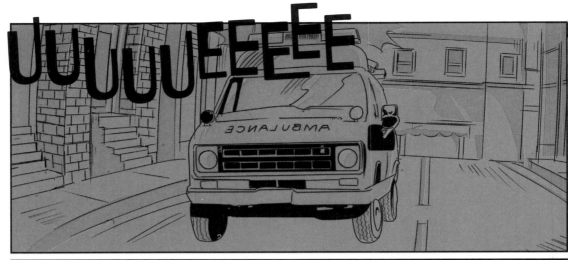

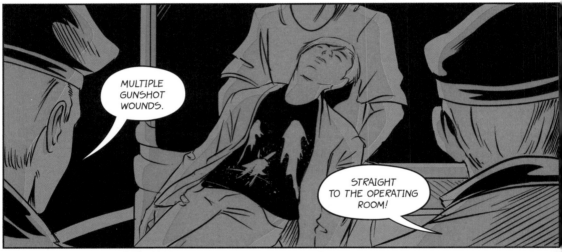

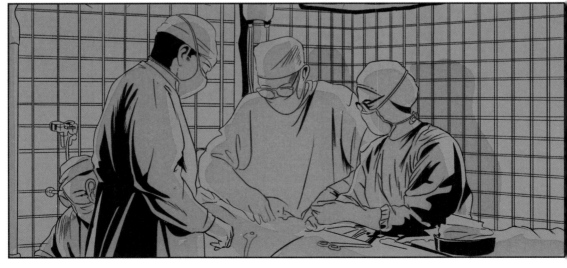

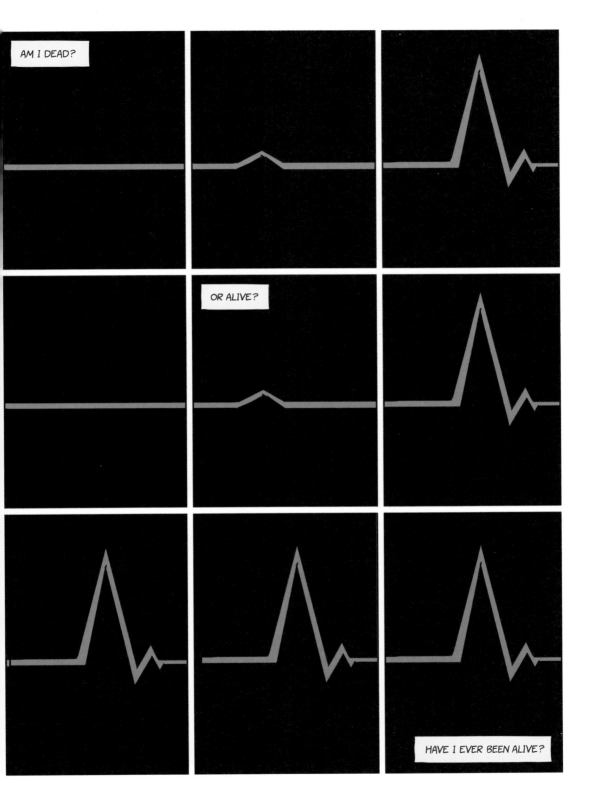

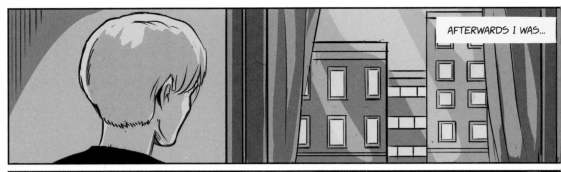

AFTERWARDS I WAS...

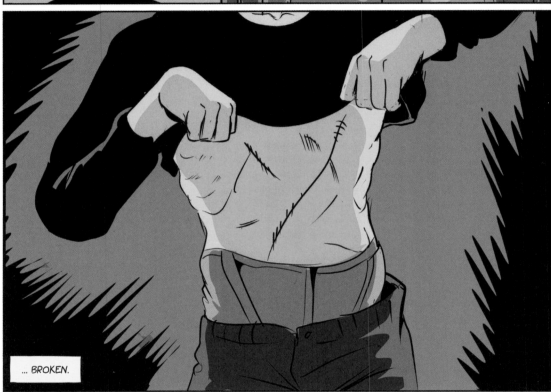

... BROKEN.

EVEN MORE ALIENATED THAN BEFORE. AND MORE SELECTIVE. MORE DISTANT FROM PEOPLE.

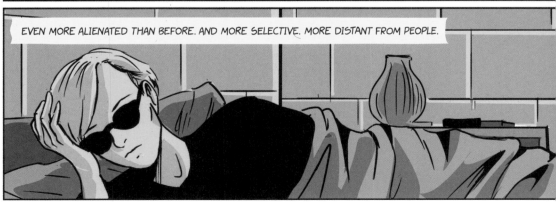

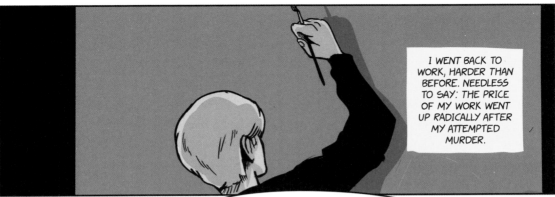

I WENT BACK TO WORK, HARDER THAN BEFORE. NEEDLESS TO SAY: THE PRICE OF MY WORK WENT UP RADICALLY AFTER MY ATTEMPTED MURDER.

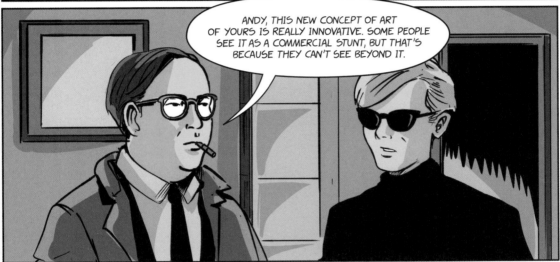

ANDY, THIS NEW CONCEPT OF ART OF YOURS IS REALLY INNOVATIVE. SOME PEOPLE SEE IT AS A COMMERCIAL STUNT, BUT THAT'S BECAUSE THEY CAN'T SEE BEYOND IT.

HENRY GELDZAHLER, THE CURATOR OF THE METROPOLITAN MUSEUM OF ART IN NEW YORK – AND A GOOD FRIEND OF MINE.

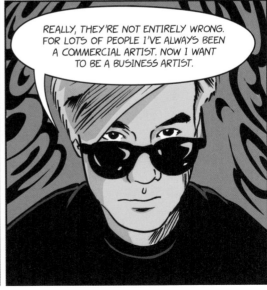

REALLY, THEY'RE NOT ENTIRELY WRONG. FOR LOTS OF PEOPLE I'VE ALWAYS BEEN A COMMERCIAL ARTIST. NOW I WANT TO BE A BUSINESS ARTIST.

CHAPTER 5

Business

ART AS WORK. WORK AS BUSINESS.
BUSINESS-ART IS BORN.
THE HARSH, LONELY EXISTENCE
OF AN ARTIST AT THE TOP.

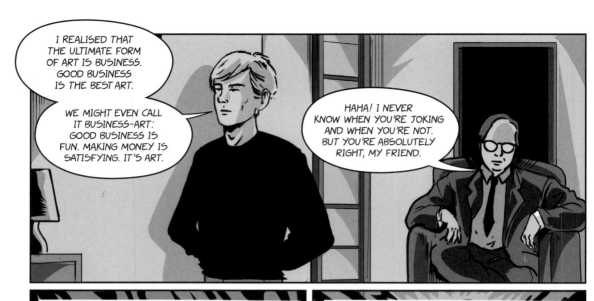

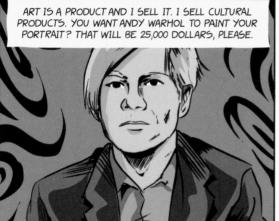

NOT LONG NOW. THAT'S A PROJECT I REALLY CARE ABOUT.

I BET YOU DO: A MAGAZINE EDITED BY YOU, THAT COVERS ART, MUSIC AND CINEMA, WITH IN-DEPTH ARTICLES AND INTERVIEWS WITH FAMOUS PEOPLE...

AND SOME VERY FINE PHOTOGRAPHY.

OH, OF COURSE! YOU HAVE ALL THESE ECLECTIC INTERESTS AND PASSIONS, AND WITH THIS YOU CAN BRING THEM ALL TOGETHER. I ADMIRE YOU.

I'M JUST A WEATHERVANE, BLOWING WHICHEVER WAY THE BUSINESS GOES.

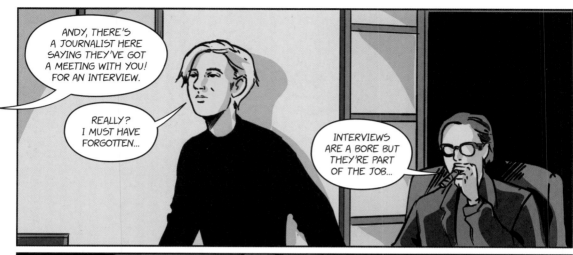

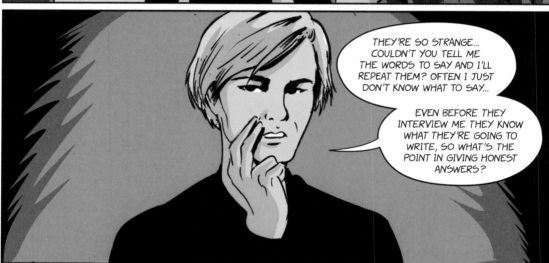

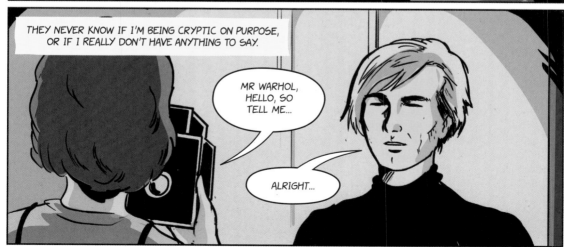

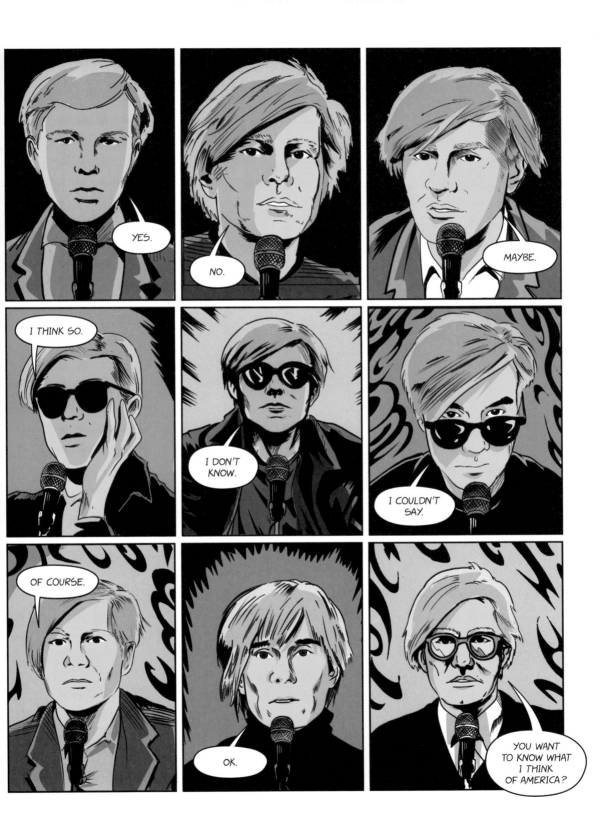

AMERICA. I ADORE AMERICA; I'M AN AMERICAN THROUGH AND THROUGH.

I LOVE EVERYTHING THAT'S AMERICAN. I LOVE BUYING THINGS, LIKE ALL AMERICANS.

I LOVE GOING ABROAD AND SEEING HOW MY COUNTRY CONTAMINATES THINGS. I WENT TO FLORENCE, AND THE MOST BEAUTIFUL THING I SAW WAS THE MCDONALD'S.

I LOVE FREEDOM, AND OTHER AMERICAN SYMBOLS.

I LIKE DEPICTING THEM.

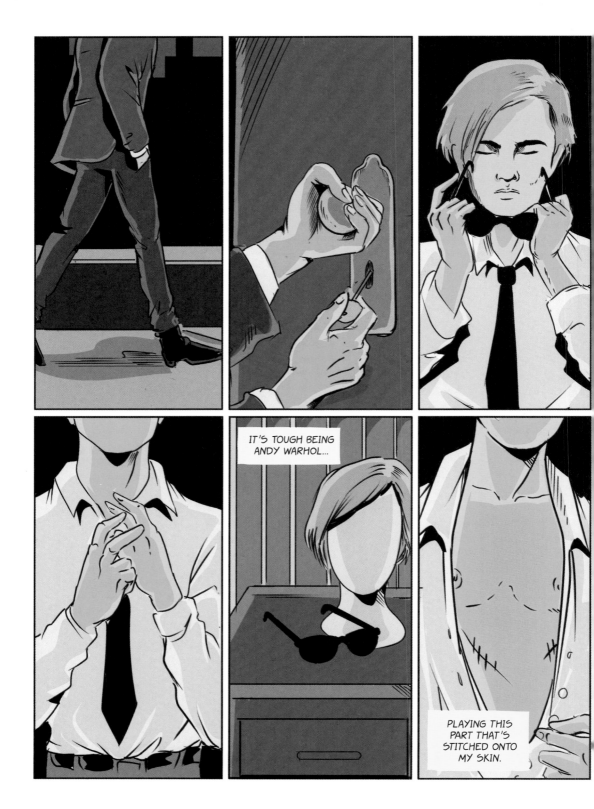

IT'S TOUGH BEING ANDY WARHOL...

PLAYING THIS PART THAT'S STITCHED ONTO MY SKIN.

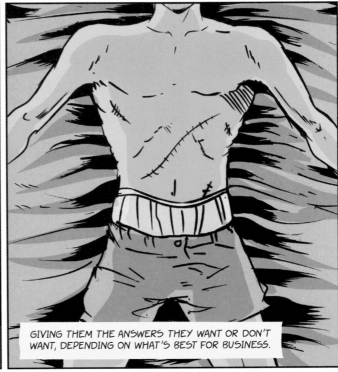

GIVING THEM THE ANSWERS THEY WANT OR DON'T WANT, DEPENDING ON WHAT'S BEST FOR BUSINESS.

AND AFTERWARDS I'M BACK HERE. WITH MY OBJECTS, MY THINGS. ALONE.

I THINK ABOUT LOVE SOMETIMES... BUT LOVE, AND SEX, ALL THAT IS SO COMPLICATED...

Always reinvent yourself

A WHIRLWIND OF EXPERIMENTATION,
AND A SINGLE GOAL:
REINVENT YOURSELF TO REMAIN TRUE
TO WHO YOU ARE.

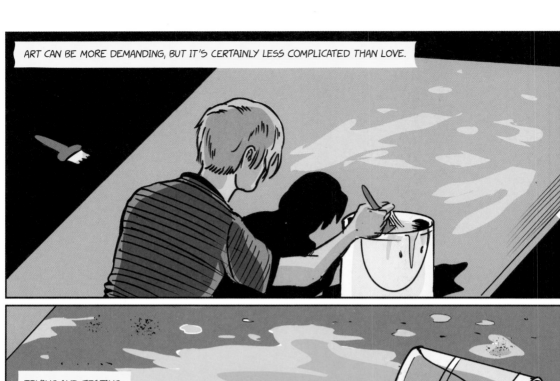

ART CAN BE MORE DEMANDING, BUT IT'S CERTAINLY LESS COMPLICATED THAN LOVE.

TRYING AND TESTING HURTS YOUR HEART A LOT LESS.

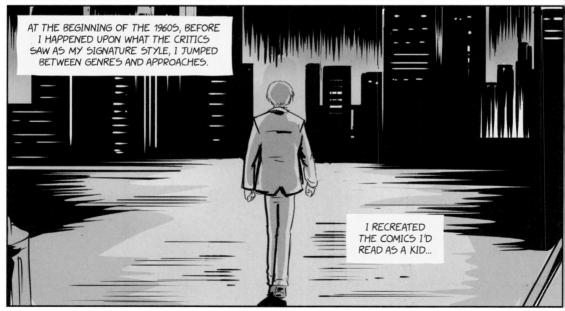

AT THE BEGINNING OF THE 1960S, BEFORE I HAPPENED UPON WHAT THE CRITICS SAW AS MY SIGNATURE STYLE, I JUMPED BETWEEN GENRES AND APPROACHES.

I RECREATED THE COMICS I'D READ AS A KID...

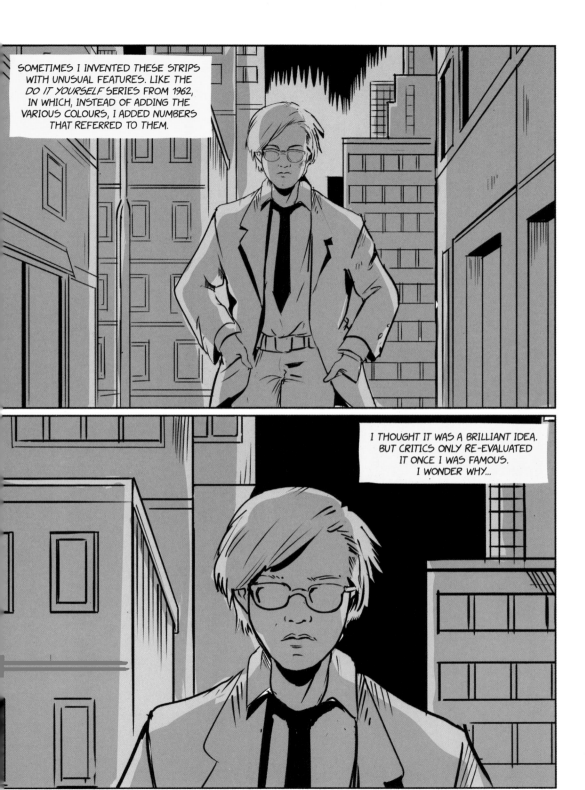

SOMETIMES I INVENTED THESE STRIPS WITH UNUSUAL FEATURES. LIKE THE *DO IT YOURSELF* SERIES FROM 1962, IN WHICH, INSTEAD OF ADDING THE VARIOUS COLOURS, I ADDED NUMBERS THAT REFERRED TO THEM.

I THOUGHT IT WAS A BRILLIANT IDEA. BUT CRITICS ONLY RE-EVALUATED IT ONCE I WAS FAMOUS. I WONDER WHY...

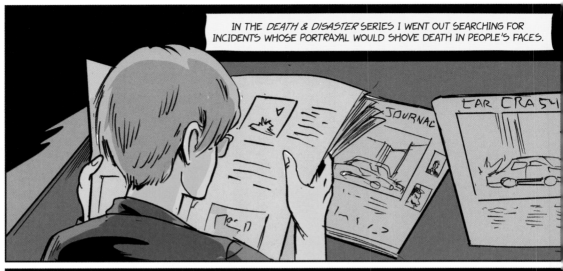

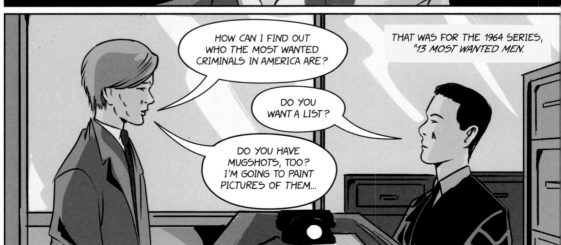

I WORKED WITH LOTS OF OBJECTS, TOO. LIKE THE *SILVER CLOUDS* SERIES IN 1966. AND MY FAMOUS SHOES.

ISN'T THIS LITTLE BALLOON CUTE? IT LOOKS LIKE A SILVER CLOUD...

YOU'VE GOTTA HAVE KETCHUP ON FRIES.

KETCHUP

AND DIFFERENT SUBJECTS: LIKE THE *COW* SERIES.

WHAT ABOUT SOME WALLPAPER WITH YOUR FACE ON IT?

...OR *FLOWERS*.

I'D BETTER TAKE A PICTURE OF THESE, TOO.

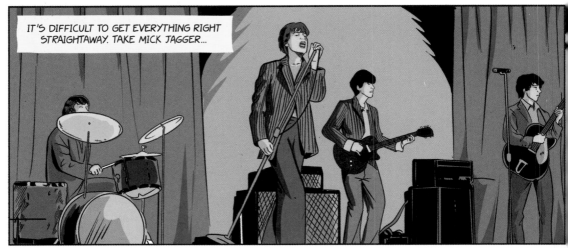

IT'S DIFFICULT TO GET EVERYTHING RIGHT STRAIGHTAWAY. TAKE MICK JAGGER...

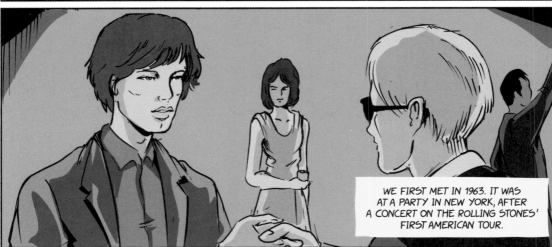

WE FIRST MET IN 1963. IT WAS AT A PARTY IN NEW YORK, AFTER A CONCERT ON THE ROLLING STONES' FIRST AMERICAN TOUR.

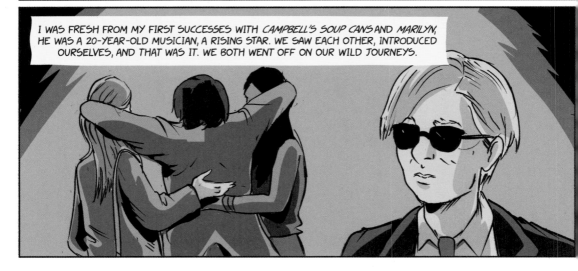

I WAS FRESH FROM MY FIRST SUCCESSES WITH *CAMPBELL'S SOUP CANS* AND *MARILYN*, HE WAS A 20-YEAR-OLD MUSICIAN, A RISING STAR. WE SAW EACH OTHER, INTRODUCED OURSELVES, AND THAT WAS IT. WE BOTH WENT OFF ON OUR WILD JOURNEYS.

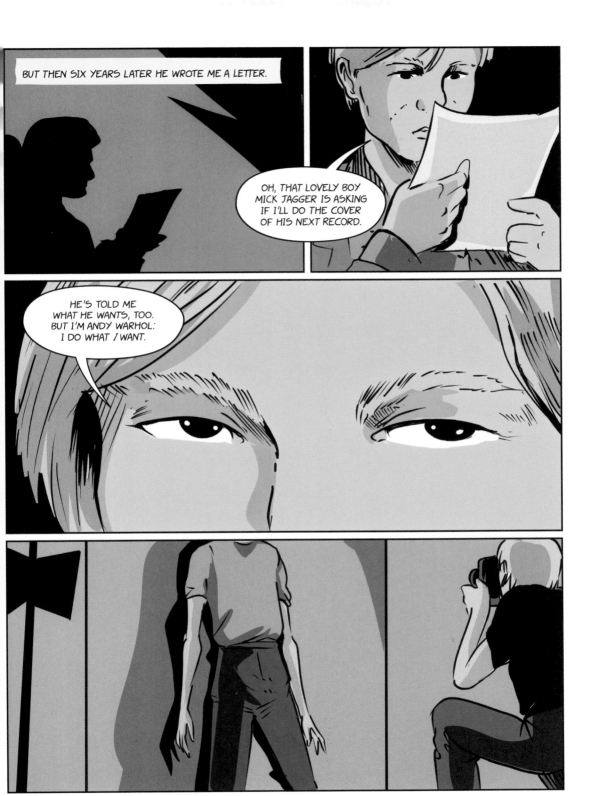

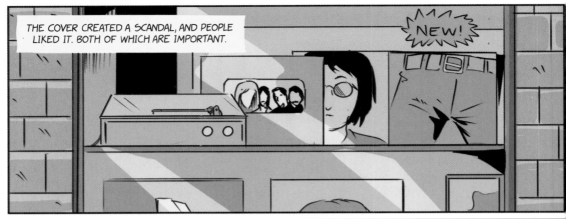

THE COVER CREATED A SCANDAL, AND PEOPLE LIKED IT. BOTH OF WHICH ARE IMPORTANT.

NEW!

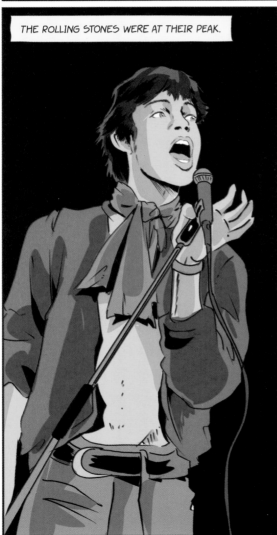

THE ROLLING STONES WERE AT THEIR PEAK.

IT WAS THE START OF A GOOD FRIENDSHIP WITH MICK.

PEOPLE SAY HE'S THIS BAD BOY, BUT ALL I'VE EVER SEEN IS JUST A GREAT ENTERTAINER AND A WONDERFUL PERSON.

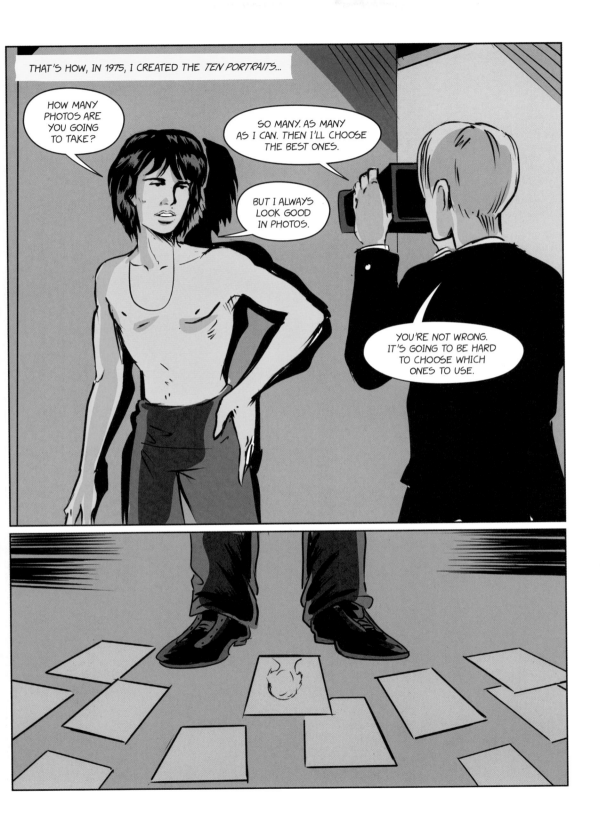

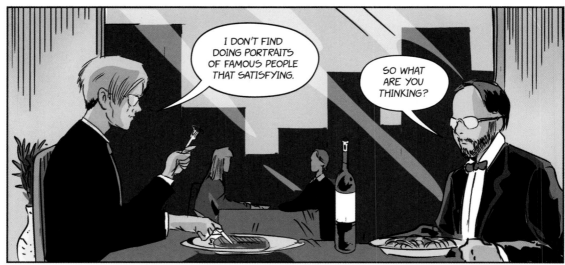

I DON'T FIND DOING PORTRAITS OF FAMOUS PEOPLE THAT SATISFYING.

SO WHAT ARE YOU THINKING?

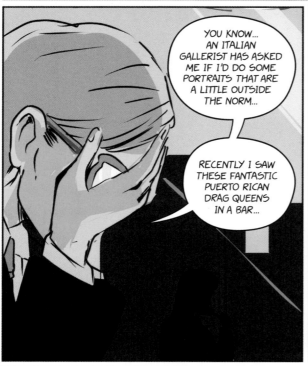

YOU KNOW... AN ITALIAN GALLERIST HAS ASKED ME IF I'D DO SOME PORTRAITS THAT ARE A LITTLE OUTSIDE THE NORM...

RECENTLY I SAW THESE FANTASTIC PUERTO RICAN DRAG QUEENS IN A BAR...

DRAG QUEENS?

YEAH, I LOVE THEM. THEY ACT LIKE COMPLETE DIVAS, AND THE WAY THEY PARODY FEMININITY IS SO FUNNY.

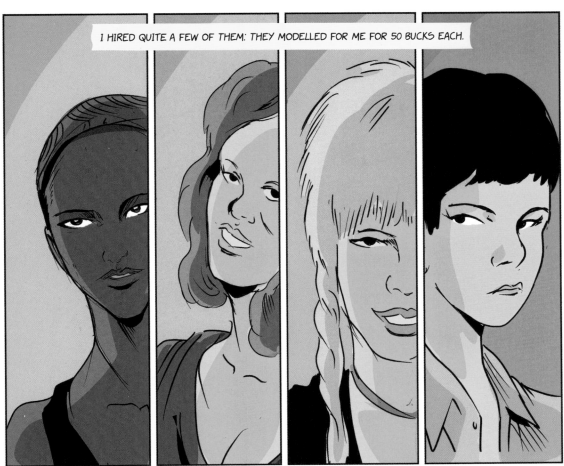

I HIRED QUITE A FEW OF THEM: THEY MODELLED FOR ME FOR 50 BUCKS EACH.

THE *LADIES AND GENTLEMEN* SERIES THAT CAME OUT OF THAT PREMIERED IN ITALY IN 1975, AT THE PALAZZO DEI DIAMANTI IN FERRARA. THEN IT WENT TO ROME.

IN A MARKET AS COMPLEX AS THE ART WORLD, MY SEARCH FOR NEW SUBJECTS AND IDEAS FOR MY PAINTINGS RANGED RESTLESSLY FROM ONE THING TO THE NEXT.

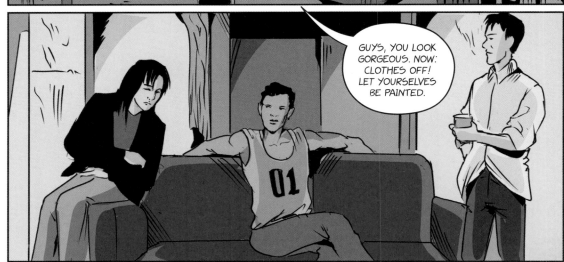

GUYS, YOU LOOK GORGEOUS. NOW: CLOTHES OFF! LET YOURSELVES BE PAINTED.

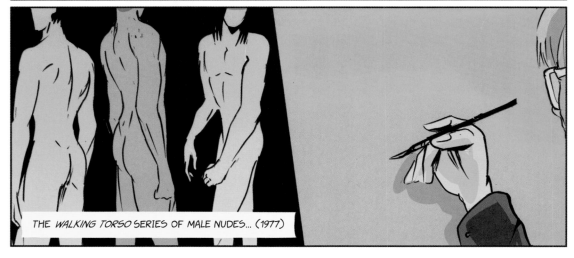

THE *WALKING TORSO* SERIES OF MALE NUDES... (1977)

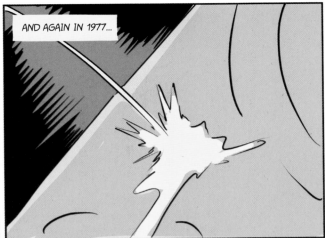

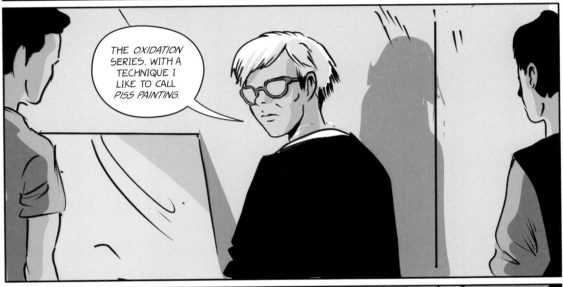

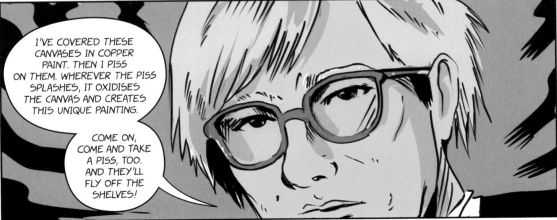

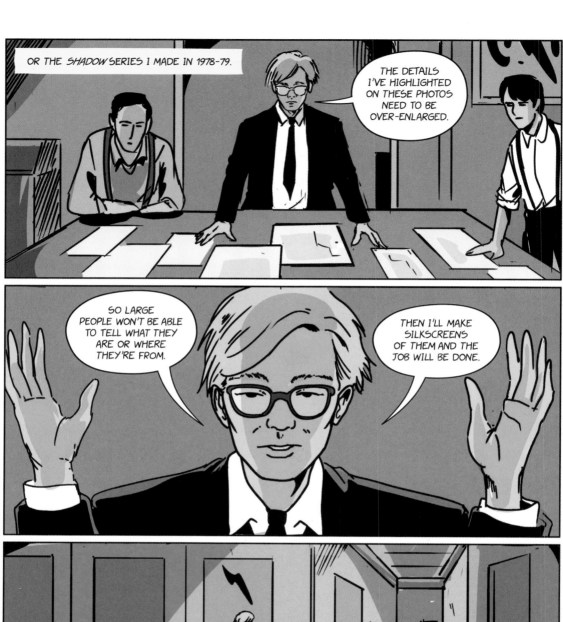

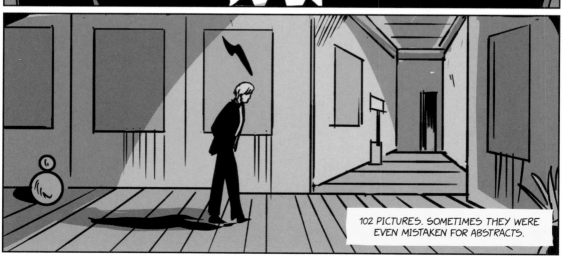

BUT AFTER ALL THIS EXPERIMENTING, BOTH THE CRITICS AND PUBLIC WERE STILL WRAPPED UP IN THE SAME DILEMMA: IS ANDY WARHOL JUST SOMEONE WHO DOES PUBLICITY STUNTS?

OR A PROPHET WHO'S KNOWN HOW TO CAPTURE THE EPHEMERAL QUALITY OF OUR AGE?

AND SO WE RETURN TO MY *BUSINESS-ART*. PEOPLE SEE THE ARTIST AS SOME KIND OF SPECIAL PERSON, BUT REALLY IT'S A JOB LIKE ANY OTHER.

AND THAT'S NOT TO REDUCE ART TO SOMETHING BANAL – BUT THE ATTEMPT TO MAKE IT MORE ACCESSIBLE. AND MORE ACCESSIBLE MEANS MORE PEOPLE POTENTIALLY BUYING AND ENJOYING IT.

Past and present

WARHOL TRIES TO KEEP PACE WITH
THE TIMES AND THE NEW THINGS DRIVING
ART - IGNORING THE FACT THAT
HE REMAINS A MAJOR REFERENCE POINT.

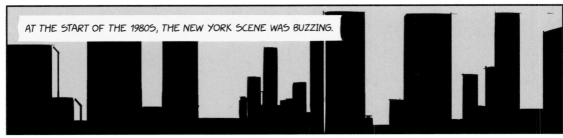
AT THE START OF THE 1980S, THE NEW YORK SCENE WAS BUZZING.

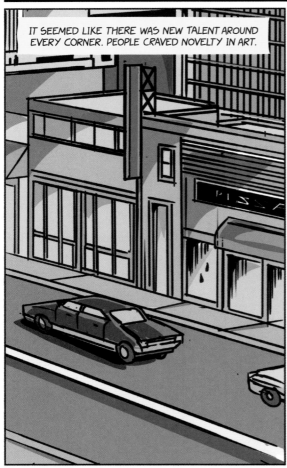
IT SEEMED LIKE THERE WAS NEW TALENT AROUND EVERY CORNER. PEOPLE CRAVED NOVELTY IN ART.

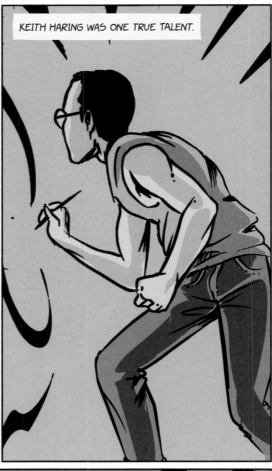
KEITH HARING WAS ONE TRUE TALENT.

HE WAS THE KING OF NEW YORK GRAFFITI.

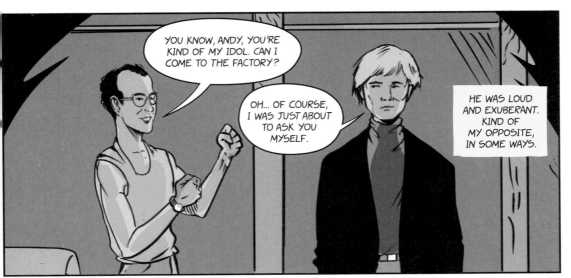

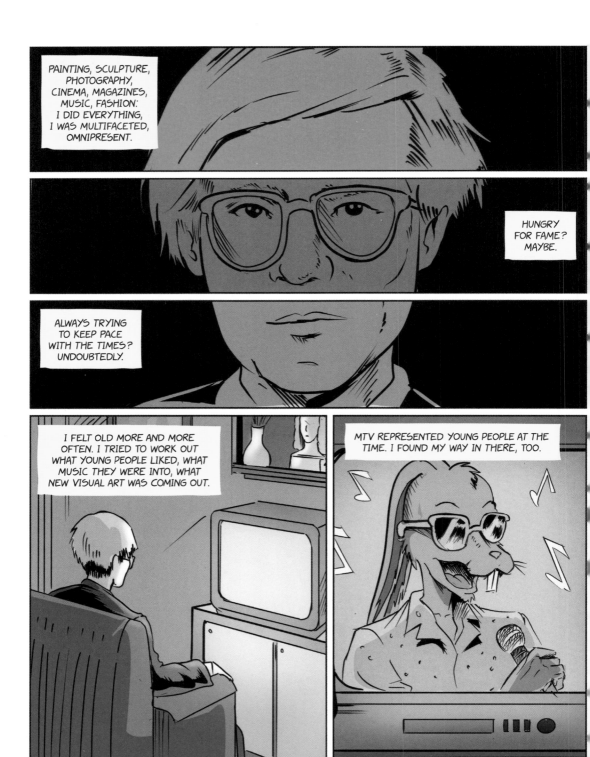

PAINTING, SCULPTURE, PHOTOGRAPHY, CINEMA, MAGAZINES, MUSIC, FASHION: I DID EVERYTHING, I WAS MULTIFACETED, OMNIPRESENT.

HUNGRY FOR FAME? MAYBE.

ALWAYS TRYING TO KEEP PACE WITH THE TIMES? UNDOUBTEDLY.

I FELT OLD MORE AND MORE OFTEN. I TRIED TO WORK OUT WHAT YOUNG PEOPLE LIKED, WHAT MUSIC THEY WERE INTO, WHAT NEW VISUAL ART WAS COMING OUT.

MTV REPRESENTED YOUNG PEOPLE AT THE TIME. I FOUND MY WAY IN THERE, TOO.

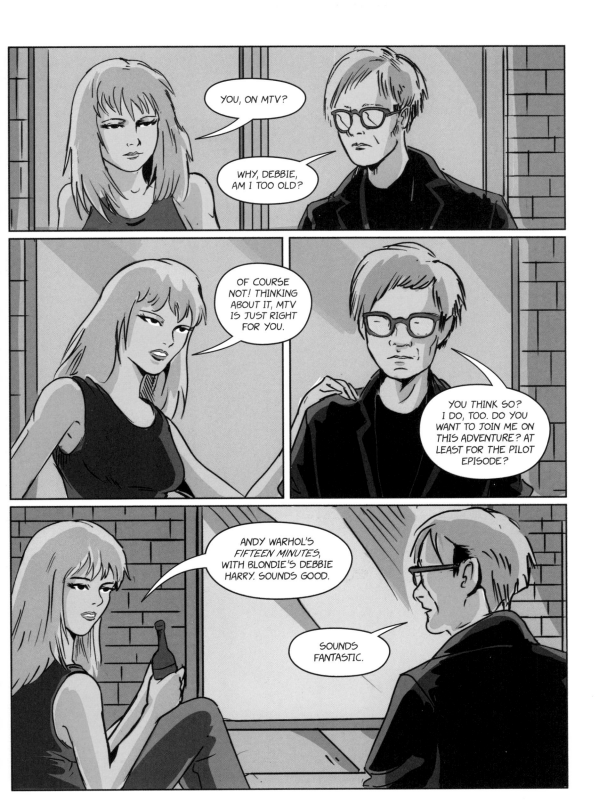

AND THEN HE APPEARED:
JEAN-MICHEL BASQUIAT,
AN INCREDIBLY
TALENTED PAINTER
AND GRAFFITI ARTIST.

WITH HIS YOUTH, HIS ENERGY.

HE WAS A SPARK OF CREATIVE ENERGY:
READY TO CATCH FIRE, AND BURN OUT.

ANDY...
ANDY WARHOL...

OH, IT'S YOU...
DO YOU WANT TO COME
BY THE FACTORY ONE
OF THESE DAYS?

HE DROPPED BY A FEW DAYS LATER. VERY QUICKLY, WE HAD FORMED THIS BOND.

WHAT DO YOU THINK, ANDY?

I DON'T KNOW, SOMETHING'S MISSING...

HOW IS IT POSSIBLE WE ALWAYS AGREE ON EVERYTHING?

IT'S SIMPLE: ARTISTICALLY WE'RE ON THE SAME WAVELENGTH.

BUT MAYBE IT WAS BECAUSE HE WAS GENUINE, DIRECT.

THE NEW YORK SCENE WAS UNSTOPPABLE; A RUTHLESS BUBBLE THAT SWALLOWED EVERYTHING UP. JEAN-MICHEL WAS THE RIGHT MAN AT THE RIGHT TIME.

THE PRESS – THE CRITICS – SAY WE'RE USING EACH OTHER: I'M FEEDING OFF YOUR FAME; YOU'RE FEEDING OFF MY TALENT.

THEY HAVE THEIR LITTLE GAMES; WE HAVE OURS. EVERYONE ACTS THEIR PART.

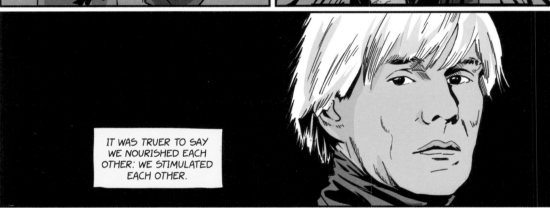

IT WAS TRUER TO SAY WE NOURISHED EACH OTHER: WE STIMULATED EACH OTHER.

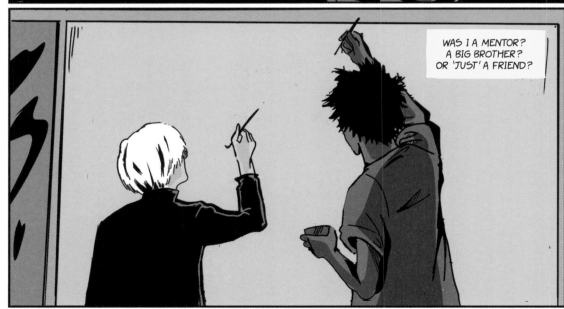

WAS I A MENTOR? A BIG BROTHER? OR 'JUST' A FRIEND?

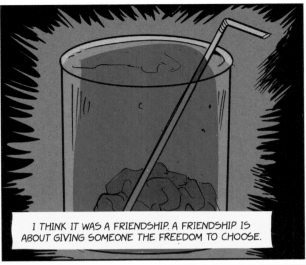

I THINK IT WAS A FRIENDSHIP. A FRIENDSHIP IS ABOUT GIVING SOMEONE THE FREEDOM TO CHOOSE.

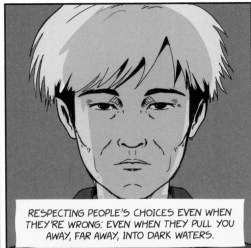

RESPECTING PEOPLE'S CHOICES EVEN WHEN THEY'RE WRONG: EVEN WHEN THEY PULL YOU AWAY, FAR AWAY, INTO DARK WATERS.

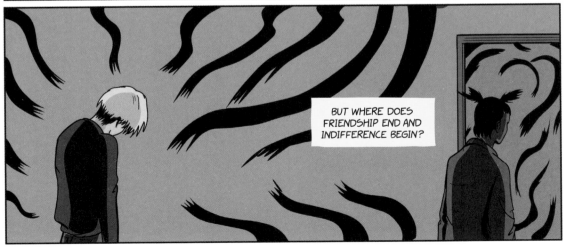

BUT WHERE DOES FRIENDSHIP END AND INDIFFERENCE BEGIN?

The end and eternity

AND THEN,
WHEN YOU LEAST EXPECT IT,
IT'S ALL OVER.
BUT IS IT REALLY?

FEBRUARY 1987.

NO, IT'S NO BIG DEAL: A GALLBLADDER OPERATION.

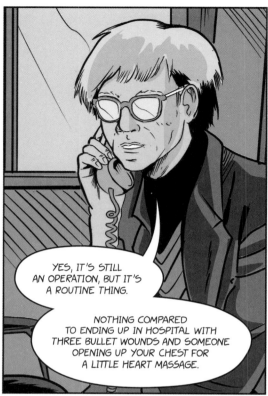

YES, IT'S STILL AN OPERATION, BUT IT'S A ROUTINE THING.

NOTHING COMPARED TO ENDING UP IN HOSPITAL WITH THREE BULLET WOUNDS AND SOMEONE OPENING UP YOUR CHEST FOR A LITTLE HEART MASSAGE.

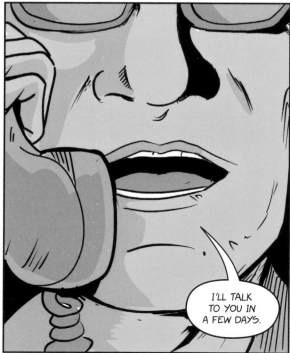

I'LL TALK TO YOU IN A FEW DAYS.

CLICK

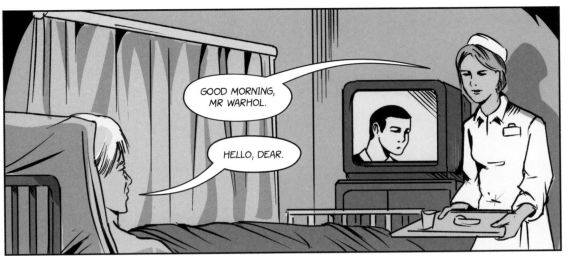

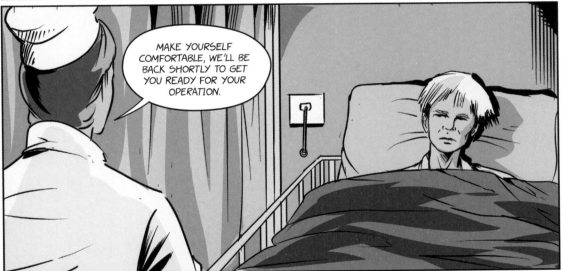

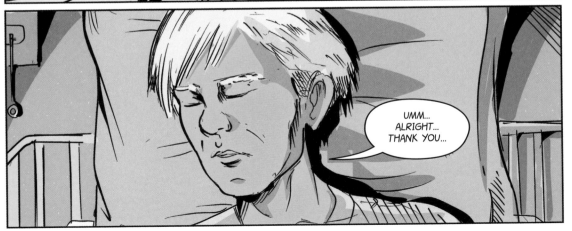

123

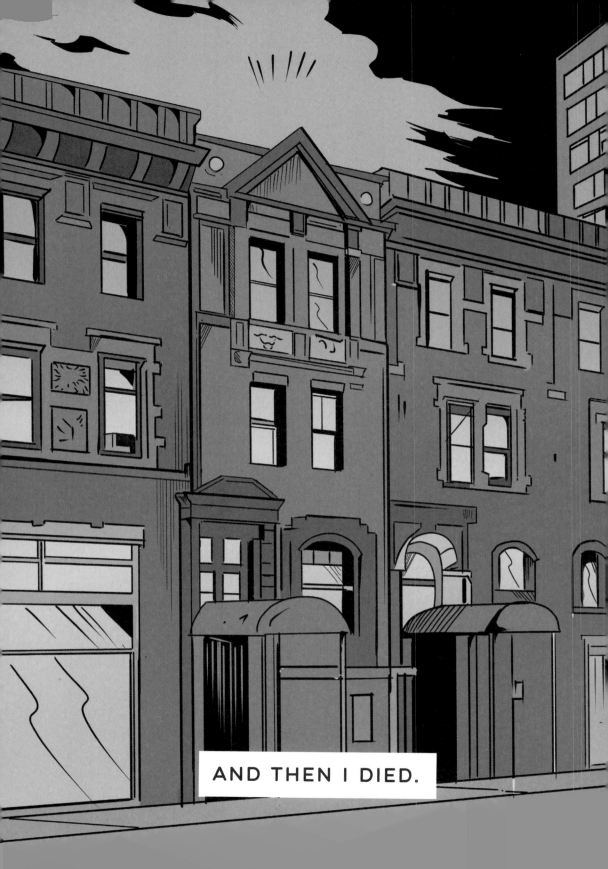

BUT
PERHAPS
I'D ALREADY
BECOME
IMMORTAL.

The end